Amy & Jim,

Love & best wishes
for a happy new year!

David
Lynn

DEDICATED TO CHRISTINA

**Without whom my canvas is empty,
my brushes unused**

*I walked our beach this morning
Indian summer was on the sand
And in the salt air and also in the sound of the water
I felt you with me, holding my hand tightly
Turning to see the sun dancing gold in your silver hair
There I felt your heartbeat, beat for beat, with mine*

RIVER RUN TO THE SEA

An Artist's Journey Through South Jersey

Paintings and photography by David Clemans

© Exit Zero Publishing
2008

ISBN 978-0-9799051-1-7

Exit Zero Publishing ★ Cape May, NJ ★ www.exitzero.us ★ (609) 886-0079

Book design by Jack Wright

Contents

Foreword ... Page 5

About the Author .. Page 6

Lindenwood ... Page 10

Cape May Point and the Delaware Bay Page 50

The Great Egg Harbor River Page 74

Still Life and Personal Page 100

Acknowledgments Page 112

On the cover:
Rustic Footbridge Over Lake Lily *1995* 16 x 20 oil on canvas

Fall On the Great Egg Harbor River

2002

30 x 40 oil on canvas
Courtesy of Tom and Peg Curran

Foreword

 here are men who live to die and men who die to live. Passion. Passion is the key. Passion is unstoppable. It is rare to know a man who lives life with the verve and passion of a Renaissance Man. Dave Clemans is one of those rare men, possessing a passion that is unstoppable.

Food. The true language of love. There is nothing sexier than the taste of a dish served up with passion. Design. Knowing and seeing how beautiful something can be if it is rendered with passion. Preservation. Understanding the importance of a rich history and having the passion

to keep it alive. And painting. The highest of all art forms – the only art that is not fleeting. Passion in clear view. Dave is a master of all of these.

Dave's paintings are a powerful representation of the life he has carved out for himself. Whether it is the gardens at Lindenwood, the Great Egg Harbor River, or the landscapes of Cape May, Dave builds these colorful worlds with the brush stroke of a tenacious young upstart. He attacks his canvases with the power and freedom of raw mastery. With layer upon layer of paint, he grinds away at the surface of convention with vivacity in a style and a voice all his own. This is what sets Dave apart – his portrayal of soft and wonderful subject matter, hewn in the violence and speed of an oil

paint cyclone. Monet meets Turner. Beauty and chaos. Life and passion.

I love looking at Dave's work, as well as his life. He is as inspiring as they come. "What is life without ceremony? It's what separates us from the animals." This is my favorite quote/lesson from Dave because it reminds us of how life can be when we live up to our potential, live with no limits, and live with passion.

Victor Grasso

Victor Grasso is regarded as one of the most provocative contemporary artists in South Jersey. Focusing on the human figure, life, death, sensuality, and quirky scenarios, Grasso's large-scale oil paintings have been shown at exhibitions throughout the state and in New York City.

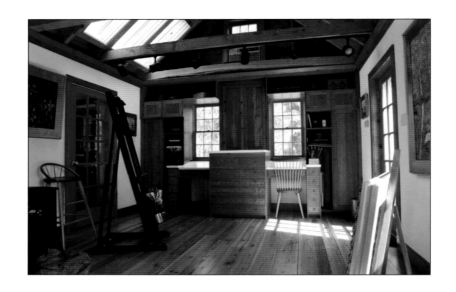

About The Artist

Only a man who is in harmony with his environment can find the contentment that many seek but ultimately find so elusive. This is a theme that has provided inspiration for some of the world's greatest novelists, essay writers and philosophers.

To hear artist Dave Clemans speak about HIS environment, his beloved South Jersey – from the Pine Barrens to the beaches and architecture of Cape May and Cape May Point – is to acquire a new appreciation of this natural wonderland.

And to view the 100 or so paintings he has created in recent years and enjoy the photographs that have inspired him is to fall deeply in love with this area…. if you haven't already. (And if you have, get ready to swoon all over again!)

"This is truly a magical place," says Dave. "I think that some people sometimes forget that." At this moment, he's talking specifically about Cape May and its surrounding charms, a community on which he has left an indelible mark, an impact which we are celebrating with the publication of this beautiful book.

But engage him on the subject of the Great Egg Harbor River, which is also generously

featured in this book, and the enthusiasm is just as contagious. "I had heard of the river before, but I'd never actually experienced it," says Dave. He and his wife Christina bought a log cabin there 12 years ago after falling in love with the area. "It's incredible. You would have no idea that you're only 15 minutes from civilization. The water is tea colored, from the iron in the soil and the run-off from the cedar trees. It's amazingly reflective. When I paint scenes from the river, people find it hard to believe those colors exist. That's one of the reasons I decided to include some photographs in this book, so I could show people just how beautiful that river really is."

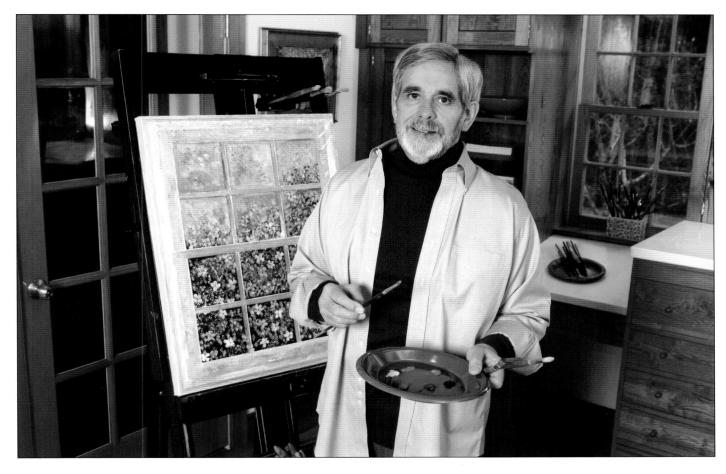

Dave Clemans at work in his studio at the historic Lindenwood home he shares with wife Christina. Lindenwood's gardens have long been an inspiration to the artist.
Photographs by Aleksey Moryakov

in Cape May County, dating from 1694 on the National Register of Historic Places.

The breathtaking gardens of Lindenwood form one of the four sections of this book and reflect another great passion in Dave's life. The three acres at Lindenwood, which are tended by grounds keeper George Lowry, are among the most beautifully landscaped on the island and are based on a 1940s blueprint that Dave found in the house.

"Some of the original plantings from that plan are still there, like the ancient crepe myrtles. When we redid the formal walled gardens, we kept the planting areas in the same place."

Gardening and painting have their similarities, says the artist. "The difficult thing is the mental part – having the imagination to come up with the idea. Gardening is much more than simply planting things in the dirt. There's a structure involved. You need to figure out your lines of sight and how each component relates to the others. Whether it's gardening or painting, once you have figured out the mental part, the actual motor skills involved in the execution are fairly straightforward."

Dave first picked up a sketchbook and a pencil at the age of eight, in his home town of Gloversville, upstate New York. "It was a drawing of Abraham Lincoln. I didn't realize until my mother died that she'd kept everything I'd ever drawn. I came across this sketch while I was going through her papers and it was signed *David Clemans, aged eight*.

Dave and Christina visit their cabin pretty much every weekend, year-round. They often get in their kayaks and paddle up and down the river. "The best idea is to do the work paddling upstream, then turn around and just drift back down. You'll see kingfishers, beavers, foxes, flocks of wild turkey, blue heron... it's paradise."

Sometimes, they'll swim in the river, and at other times they'll climb into inner tubes with their grandchildren (they have nine in all) and simply float around the oxbow that surrounds their cabin.

"You're in the middle of the pristine Pine Barrens... it's something else," says Dave.

With all of that inspiration, it's no surprise that Dave spends time painting in his rustic paradise. He and artisan Lew Thomas built a beautiful little studio by the side of the cabin (which they had to re-set on new foundations after a flood swept away the original foundation in 2007).

Most of his paintings, though, happen in the gorgeous studio Lew and George Lowry built at Lindenwood, the historic home that Dave and Christina bought in 1985. It's on Sea Grove Avenue, which is technically Lower Township but is a short bicycle ride from the heart of Cape May Point. Lindenwood is arguably the oldest surviving house

Dave Clemans designed the gardens at the Robert Shackleton Playhouse of the Cape May Stage and was closely involved with the restoration of the building, work which was recognized when the project won beautification awards in 2007 from the city, county and state.

On the right, white mandevilla, purple coleus and New Guinea impatiens frame a shot of the fountain, which was made by Haddonstone, an English product cast to simulate carved limestone that was used in some of Europe's most famous gardens. The finial behind the fountain is an octagonal Turkish dome that mirrors the domed top on the theatre's belvedere, an example of early Victorian exotica.

He found his way to the Jersey Shore by way of an education at the University of Maryland, the Maryland Institute of Art in Baltimore, and marriage to Christina Clemans, with whom he ran an art gallery in Westfield, New Jersey before the couple bought a summer home in Cape May Point in 1978.

They continued to run the art gallery while enjoying regular trips to the Shore, before making the tip of the Garden State their permanent home in 1983. Two years later, they bought and meticulously restored the John F. Craig House, on Cape May's magnificent Columbia Avenue. Dave was the innkeeper, running the B&B and cooking the breakfasts, while Chris established her growing real estate company, Chris Clemans & Co.

In 1993, Dave indulged his other love – food – when he opened Cucina Rosa, which has become a popular restaurant on the Washington Street Mall. It's run by Dave's stepson Guy Portewig, though Dave still helps to concoct the sauces and contribute to the menus.

As Dave says about this period of his life in Cape May, "Little from that time had relevance to the pursuit of painting." But it DID allow him to establish the kind of security that would enable him to eventually pursue his true vocation.

And there seems to be no end to the sources of inspiration that lie around him.

In 2003, Dave and Christina purchased and restored a pair of cottages on Batts Lane in Lower Township. One of the cottages, the Owen Coachman House, is a circa 1700 whaler's cottage, moved south from Town Bank as the Delaware Bay waters encroached. In 2005 the cottage was placed on the state and national registers of historic places and in 2006 the couple's wonderful restoration of the Owen Coachman House was awarded with an Historic Preservation Award by the State of New Jersey.

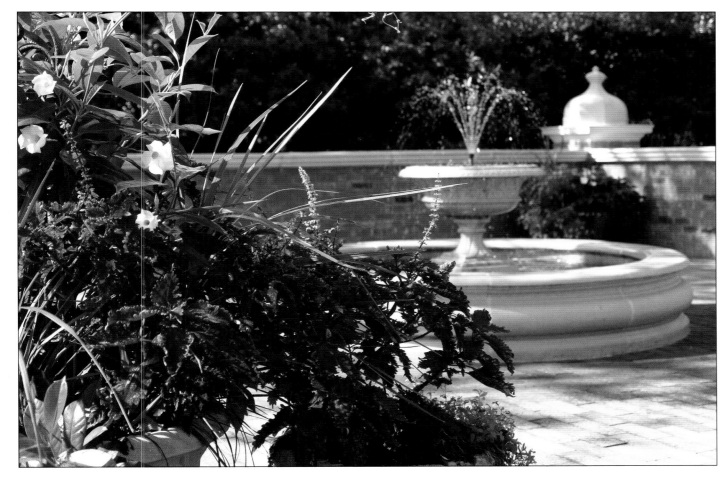

Dave's love of preservation, the arts – and landscaping – led him in 2005 to become closely involved with the restoration of a former church which operates as the playhouse of local theatre company Cape May Stage. His design for the landscaping of the theatre's gardens was completed last summer and breathed new life into the center of the town. Dave also worked closely with his friends Jim Moffatt and Tom Carroll to completely renovate the interior of the 1851 building. The restoration of the theatre building and gardens won three separate historic preservation awards.

"The theatre lies at the heart of the community in Cape May and it was a pleasure to contribute. It's my belief that when you truly love a place, it's your duty to give back in any way you can. This is what creates a special kind of place," says Dave.

All of these buildings and grounds, from the Great Egg Harbor River to a cherry tree at Lindenwood, have served extensively as subject matter for many of Dave's paintings.

"Discovering the visual uniqueness of southern New Jersey, from Cape May, the city, sea and bay up to that great wilderness of the Pine Barrens with its small rivers and unusual flora and fauna, have greatly inspired me and provided limitless vistas for the brush and canvas," says Dave.

All of that inspiration, all of that love, has been distilled into this book. I hope this collection of paintings and photographs serves as a reminder of how lucky you are to live here, dream of living here, or regularly visit!

Jack Wright

Jack Wright, a former magazine and newspaper editor in London and New York, is the editor and designer of River Run to the Sea: An Artist's Journey Through South Jersey. *He is editor/publisher of Exit Zero Publishing.*

CHAPTER ONE

Lindenwood

Lindenwood

The site of Sea Grove (Cape May Point) was purchased from The West New Jersey Society in England by Jonathan Pyne the elder in 1687. Pyne died in 1694 and willed his house and 300 acres of land to his son, Jonathan, Jr., who sold it to Henry Stites in 1712. The property remained in the Stites family until the marriage of Jane G. Stites in 1835 to Alexander Whilldin and was conveyed by them to the Sea Grove Association in 1875. The house built by Jonathan Pyne still stands on Sea Grove Avenue and is perhaps the oldest house in Cape May County. It is shown circled in the top right of this illustration, which was used as a sales brochure for the new Sea Grove development. The house was given the name "Lindenwood" in the 1930s because of an ancient Linden tree in the front yard which is estimated to be 250 years old. Lindenwood, its gardens and grounds, have served as inspiration for many of my paintings.

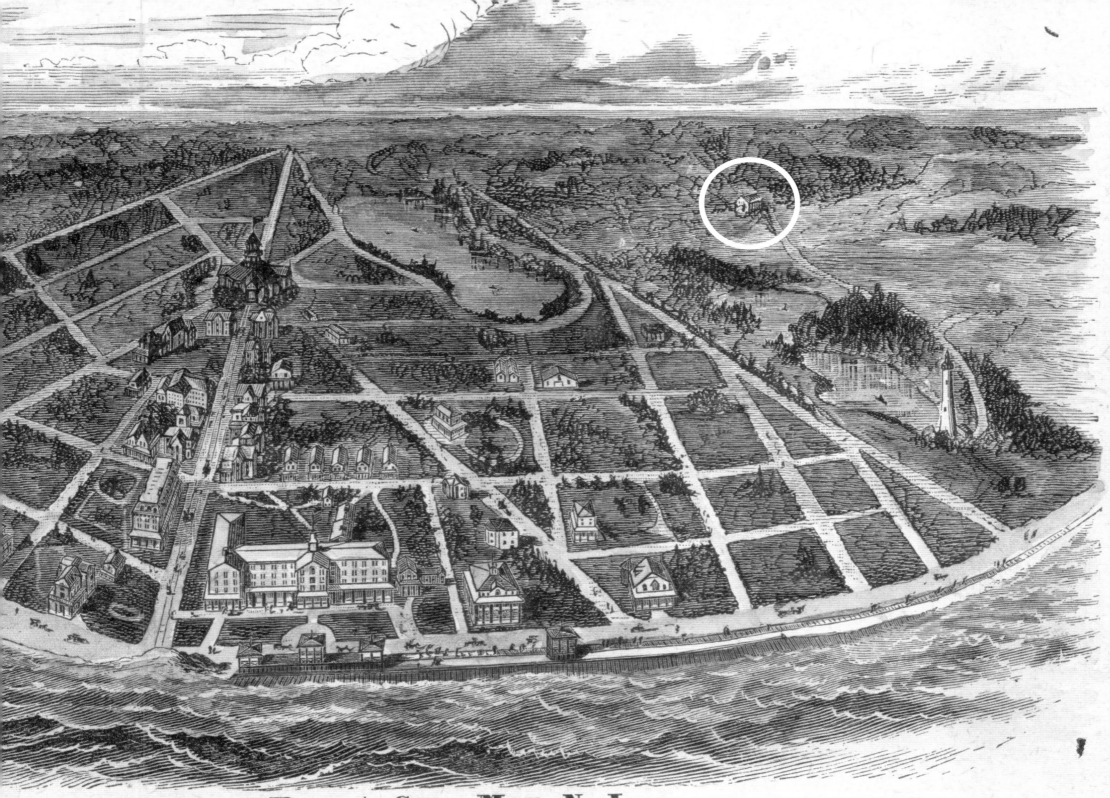

Sea Grove Resort, Cape May, N. J.

Lindenwood
1998
8 x 10 oil on canvas

Historic Home

In 1978, on our way to our little cottage on Yale Avenue in Cape May Point, we drove, as always, along Sea Grove Avenue. As we passed this handsome federal-style house with a very large and inviting side yard, Christina's words still echo in my memory: "If that house ever goes on the market, I will have it!"

In 1985, at her real estate office in Cape May, a new sales listing crossed her desk – there it was and within the day it was hers! Only months later did we learn of its place in local history, its great age and significance. The house was placed on the National Register of Historic Places in 1996.

Early in the day the front of the house is dappled in sunlight through the linden tree. This warm and inviting sight was the impetus for the painting on the opposite page.

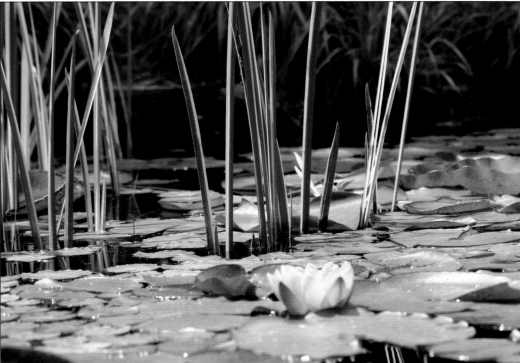
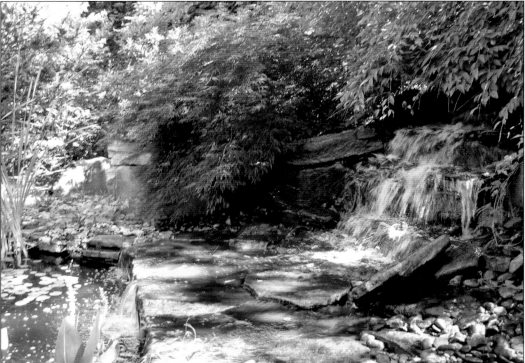

Rock Garden, Pond And Waterfall

My original design for a small pond and rock garden somehow grew into a large-scale landscaping feature with a very natural and almost magical retreat. Featured in many of my paintings, the pond and waterfall are on a direct sight line from the house conservatory through the perennial gardens. I have frequently used this landscaping feature in my paintings, from close-up pond views to the massive rocks visible through flower gardens close to the house.

Moonlight On Waterfall
2002

11 x 14 oil on canvas

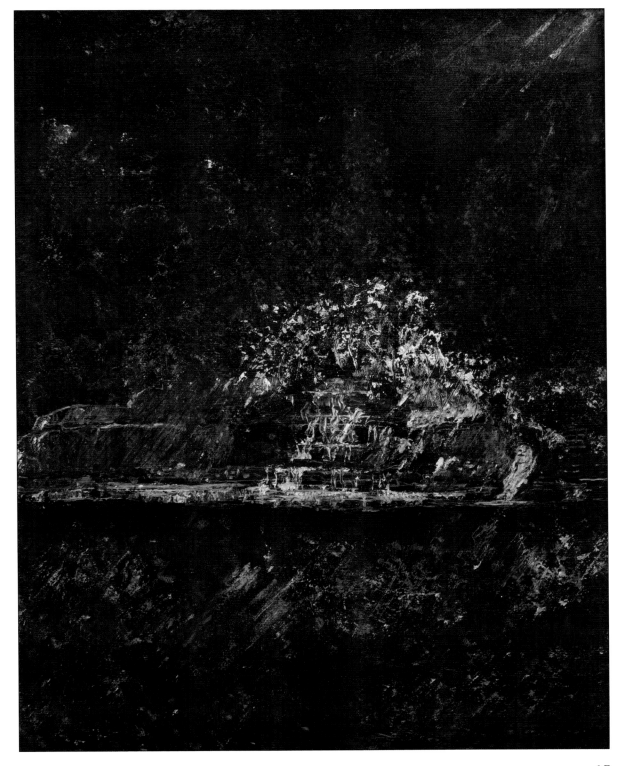

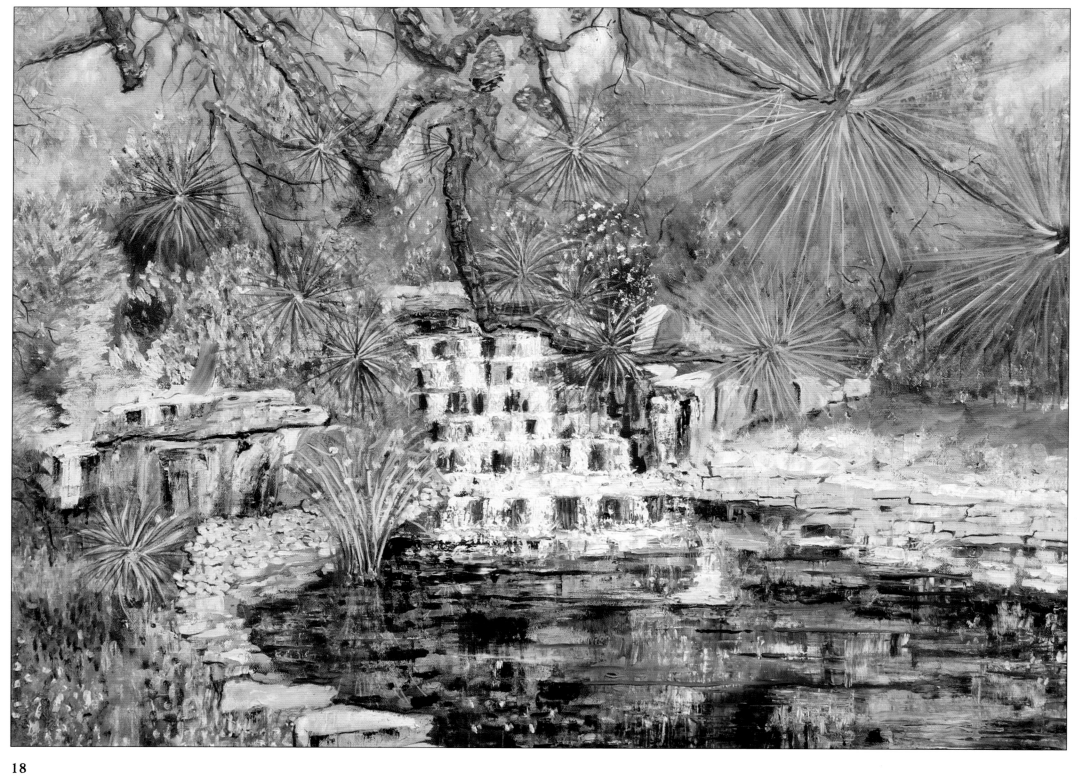

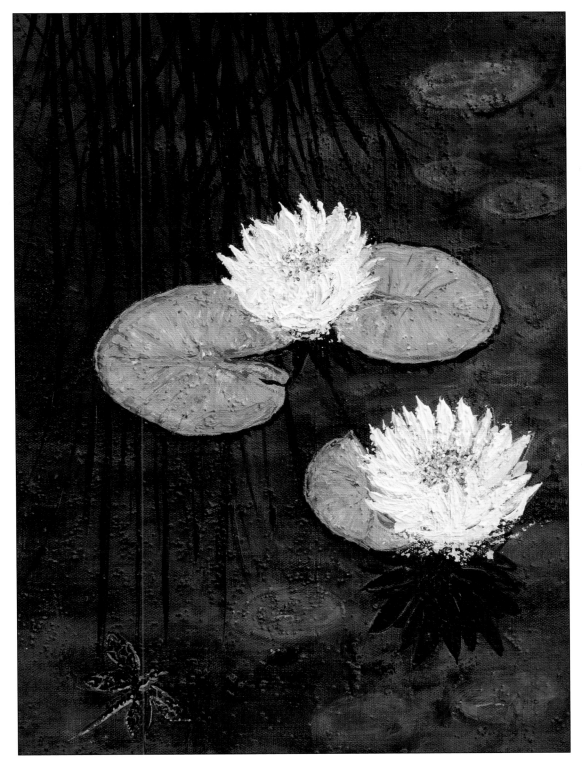

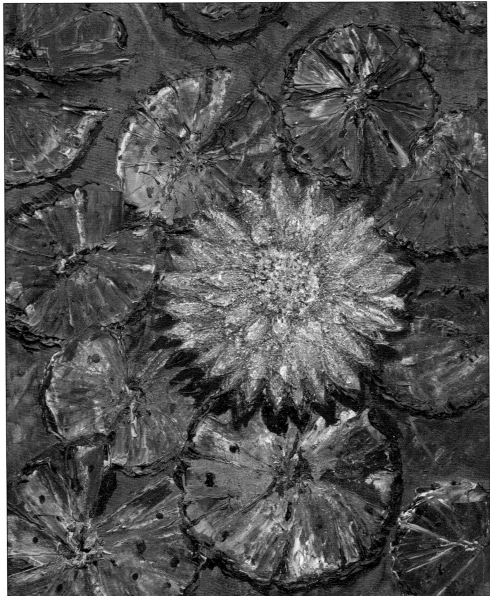

The pond beneath the waterfall is home to assorted colored water lilies and lotus flower, koi, carp and shubunkin... and attracts a huge following of birds and dragonflies, whose larvae feast on the tadpoles.

Left: **Waterfall With Black Pine** 2000 24 x 30 oil on canvas

Center: **Dragonfly** 2000 12 x 16 oil on canvas

Right: **Double Lotus** 2004 11 x 14 oil on canvas

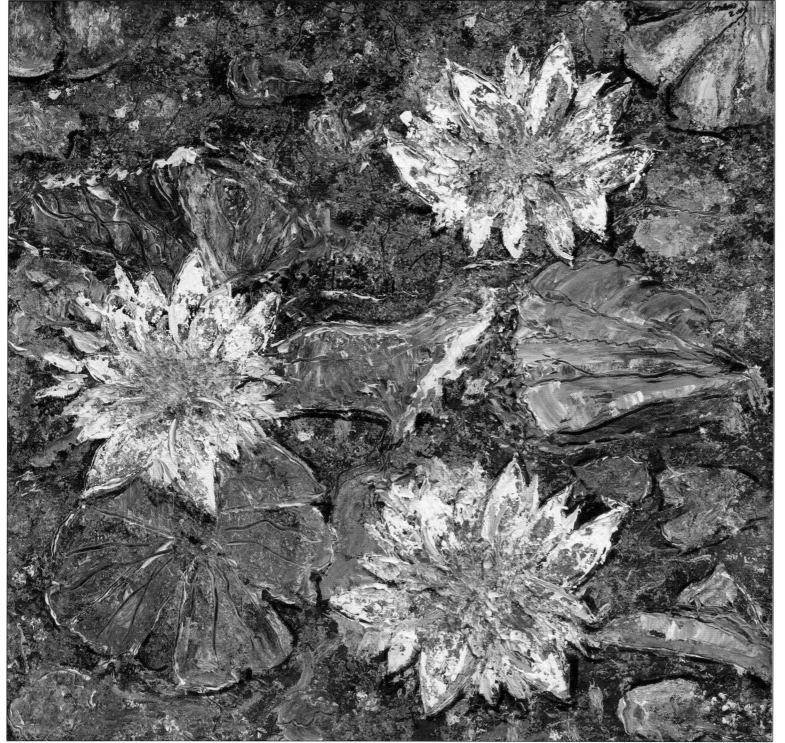

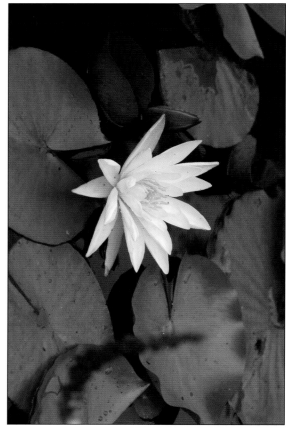

Water Lilies
2005
18 x 18 oil on canvas

Weeping Cherry
2003
8 x 10 oil on canvas

Lindenwood's Gardens

Formal gardens were installed at Lindenwood in 1946 by the Main family. They consisted of a perennial garden surrounding a grass panel, walkways with ornamental trees, a rose garden with an exquisite pink climber, a courtyard with a splendid white cherry tree and other smaller plantings. Some of these, including the cherry tree, the climbing roses, camelias and crepe myrtles have survived. We have painstakingly restored the other plantings in the manner of the original plan. There are notable large old trees, including oaks and chestnuts, an exquisite and rare American elm and that 250-year-old Linden tree for which the house and grounds were named.

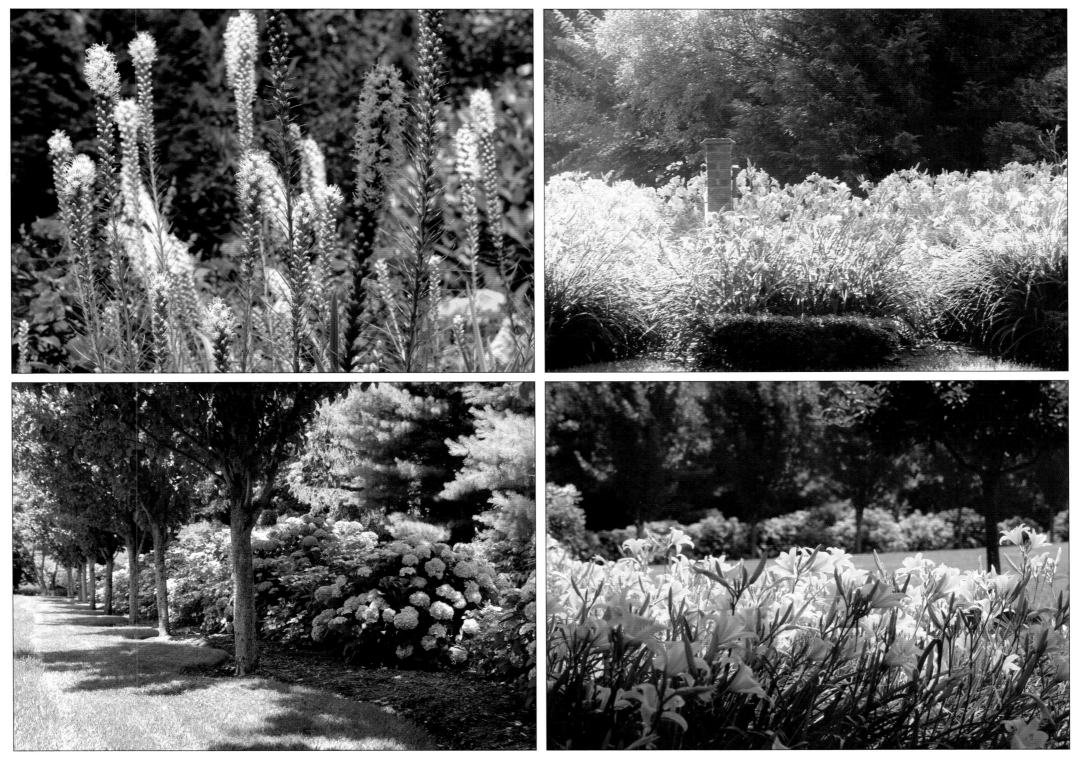

Nikko Blues 2007 11 x 14 oil on canvas **Lace Caps** 2007 8 x 10 oil on canvas

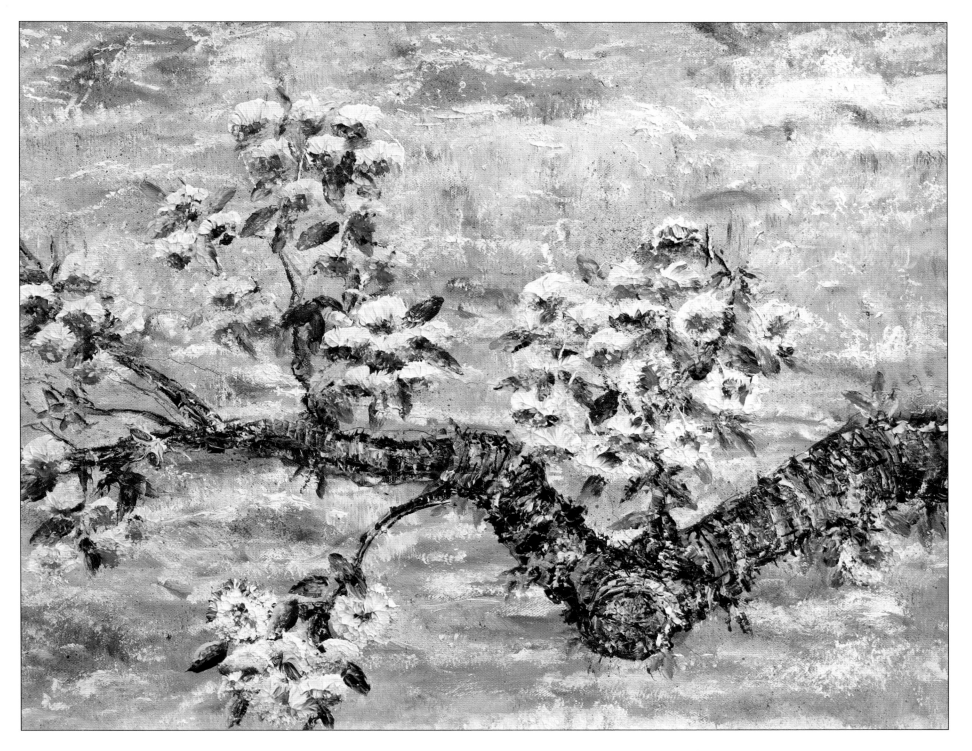

Blue Walled Garden 2007 18.5 x 21.5 oil on canvas

Cherry Blossom Sky 2003 16 x 20 oil on canvas

Nocturnes

Late winter's evening showing oaks and pitch pines. The nocturnal painting is influenced by the great American classical painter James McNeil Whistler (see page 93).

Day's End
1999
18 x 24 oil on canvas

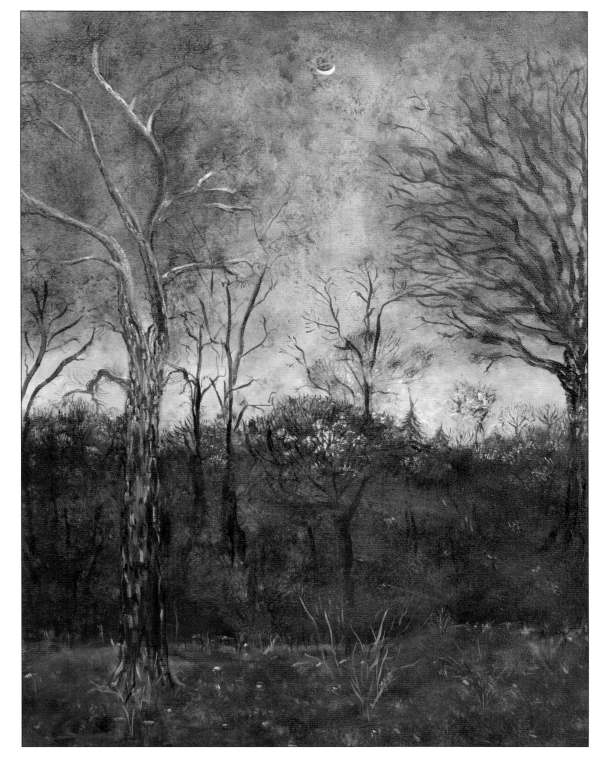

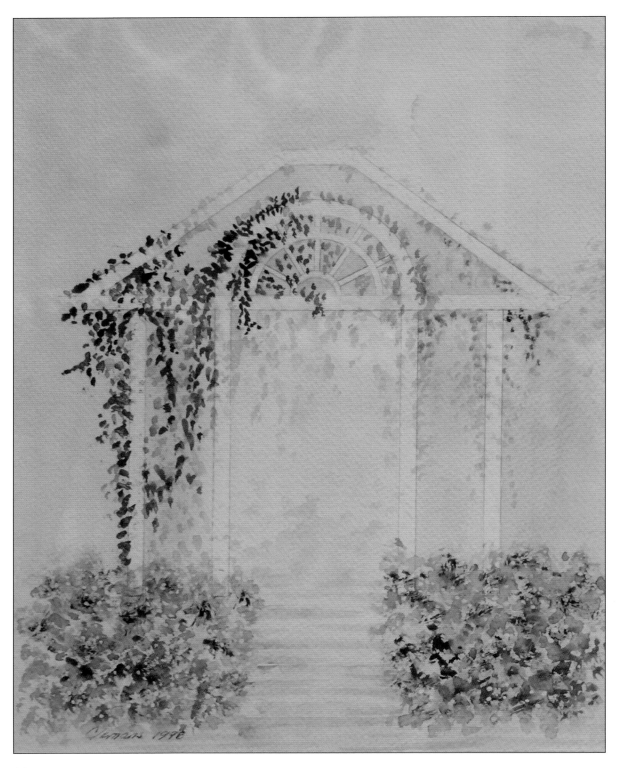

Clematis Cascade

1998

9 x 12 watercolor

The pergola at Lindenwood was painted
on a misty summer's morning.

After The Snow

2004

16 x 20 oil on canvas

This painting depicts the pond
and the waterfall.

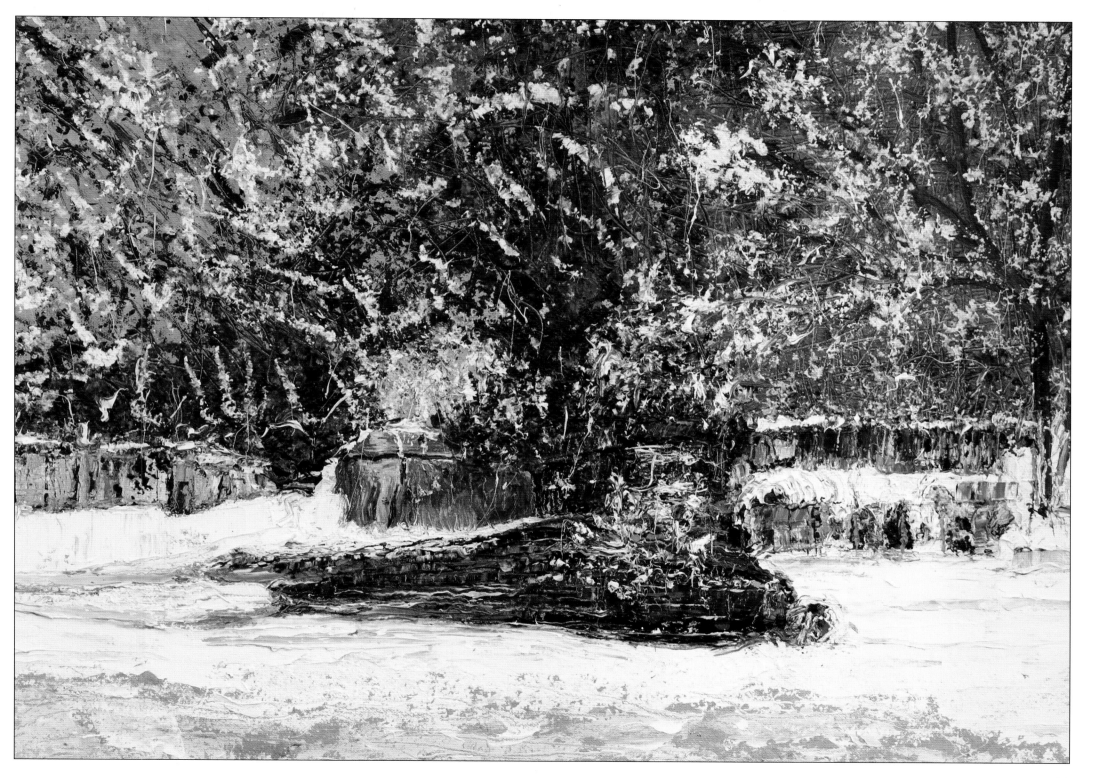

31

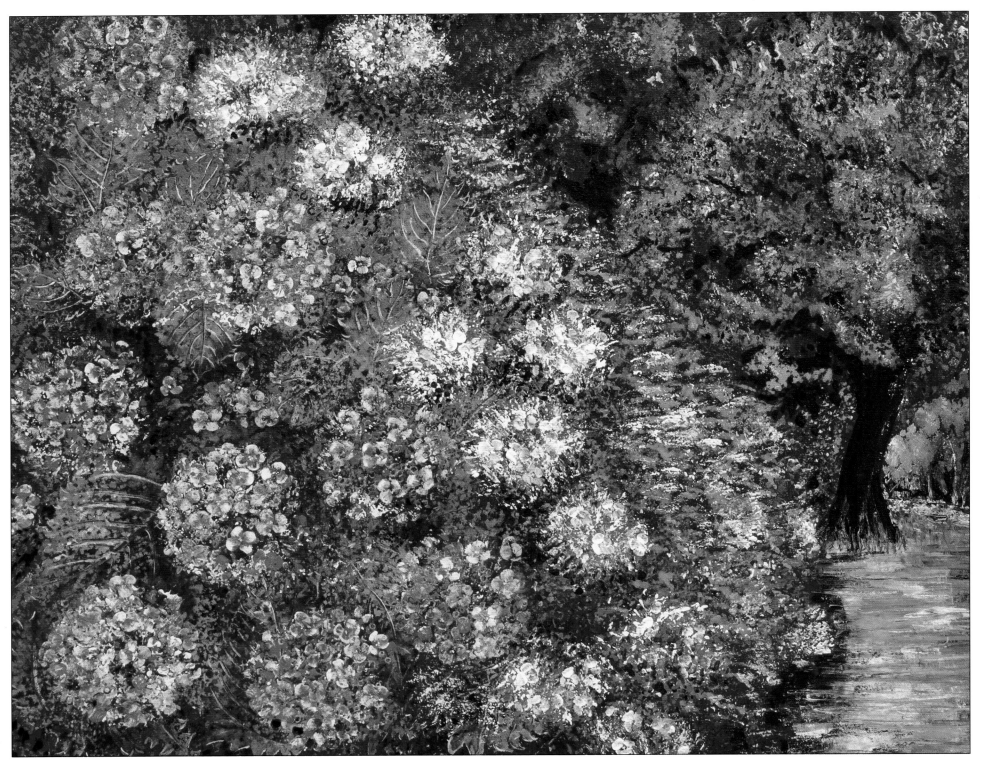

Left:
**Hydrangea
Drive**
2007
24 x 30
oil on
canvas

Right:
**Oakleaf
Hydrangeas**
2007
24 x 30
oil on
canvas

32

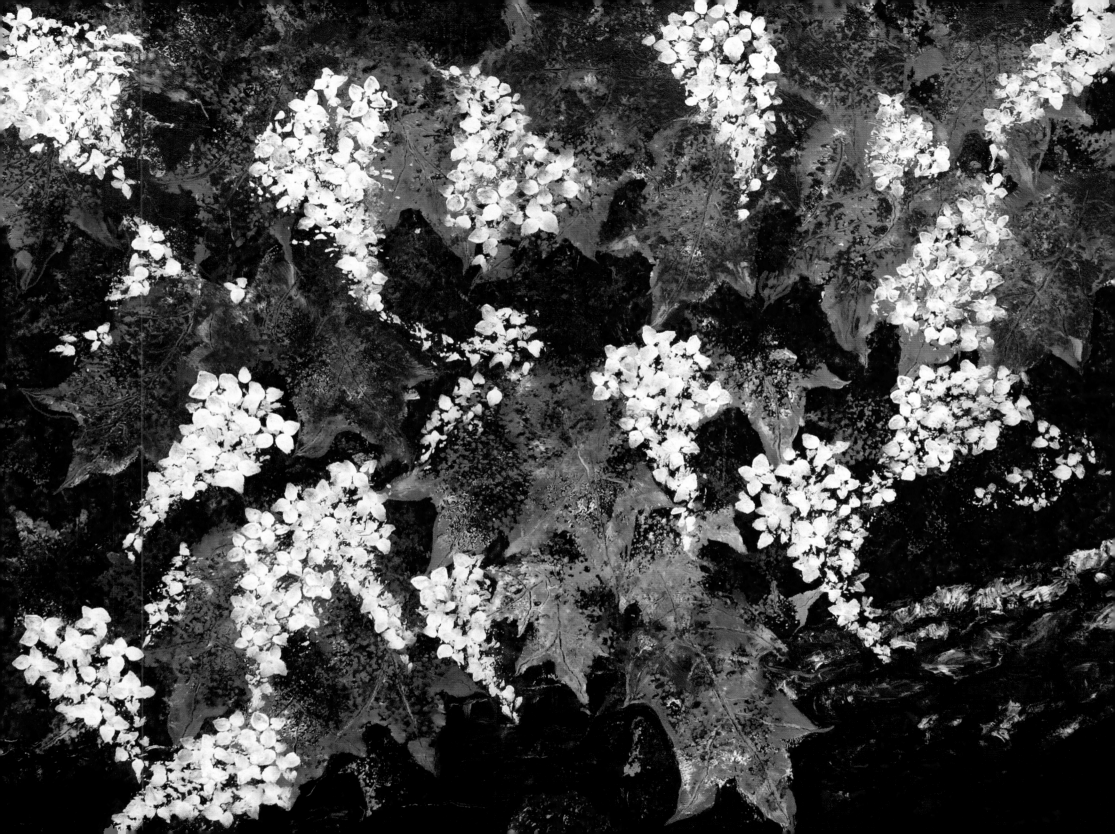

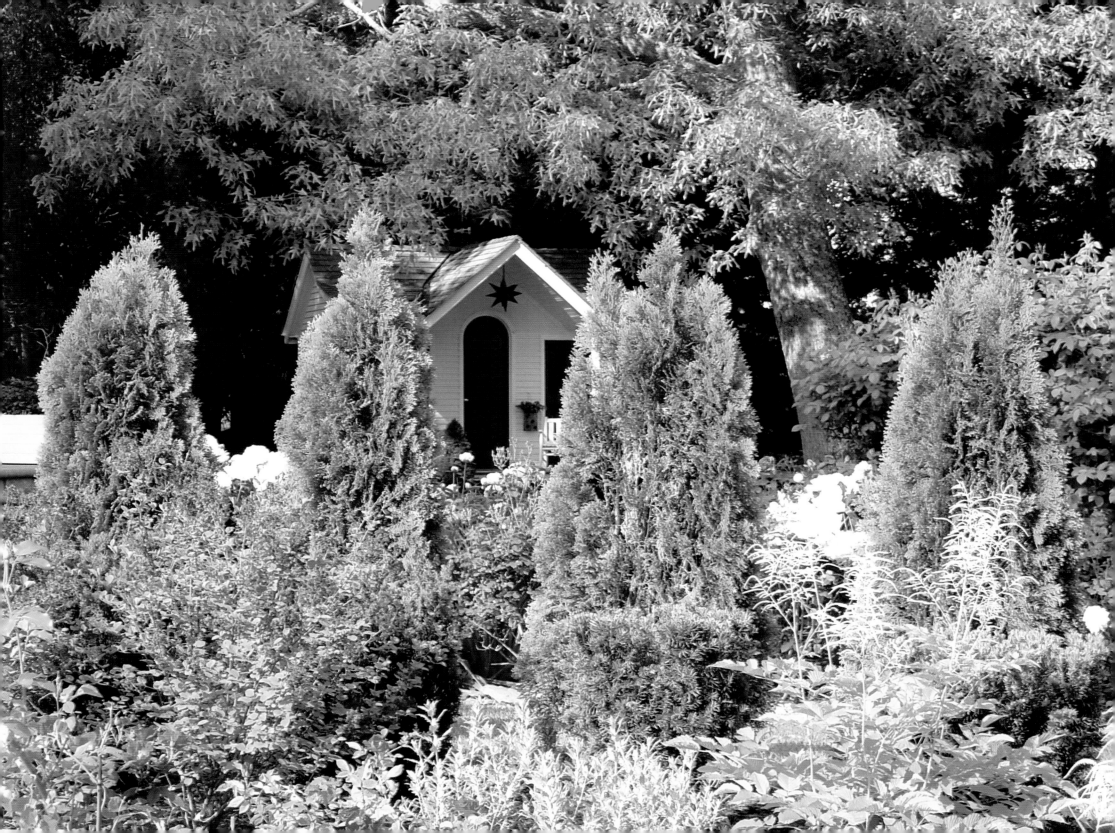

Fairy of Starlight Cottage

2001

24 x 30 oil on canvas

The grandchildren were so fascinated with Starlight Cottage that they wished to add a bit of myth and magic. The suggestion of a woodland fairy to protect the cottage was offered and to their delight the Fairy of Starlight Cottage was created.

Starlight Cottage

2007

24 x 30 oil on canvas

Starlight Cottage was created to satisfy Christina's desire that our grandchildren have a playhouse filled with the fancies that children love. It was completed in 2000 and remains their favorite place to work on paintings and projects, the results of which seem quite inspired.

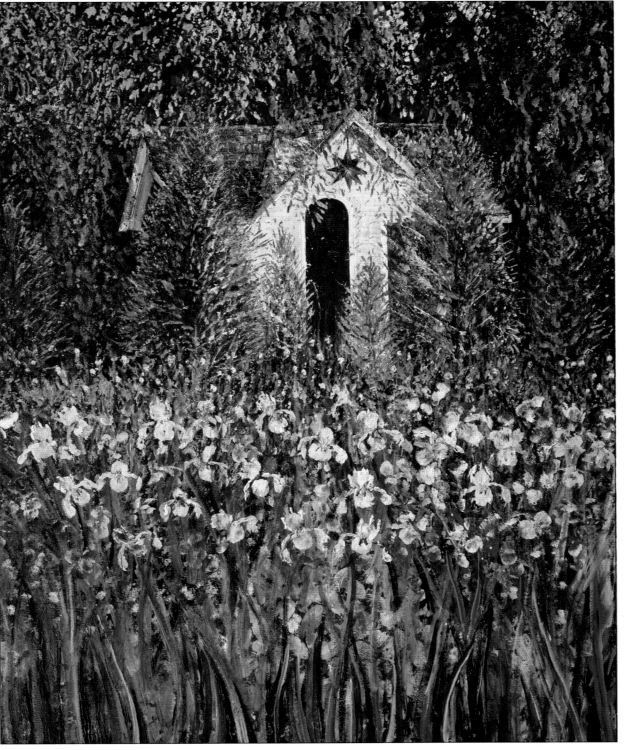

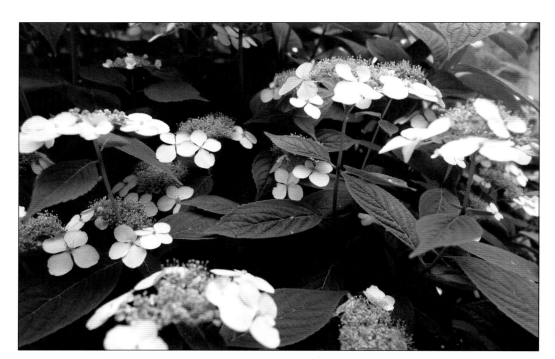
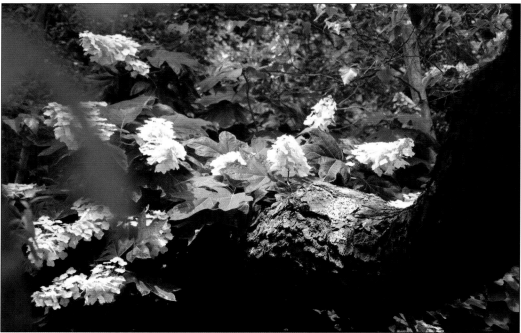

Brief Visit

Water the honeysuckle

Last on the list

My fist around the nozzle

The water arching toward its target

A fine mist falling

A faint calling from the left

Inches away the soft vibration of tiny wings

Grey-green at first

Then turning into sunlight

The ruby-throated flight of

A honeysuckle rose

Poem by David Clemans, 2001

Sage Over Irish *2007 24 x 30 oil on canvas*

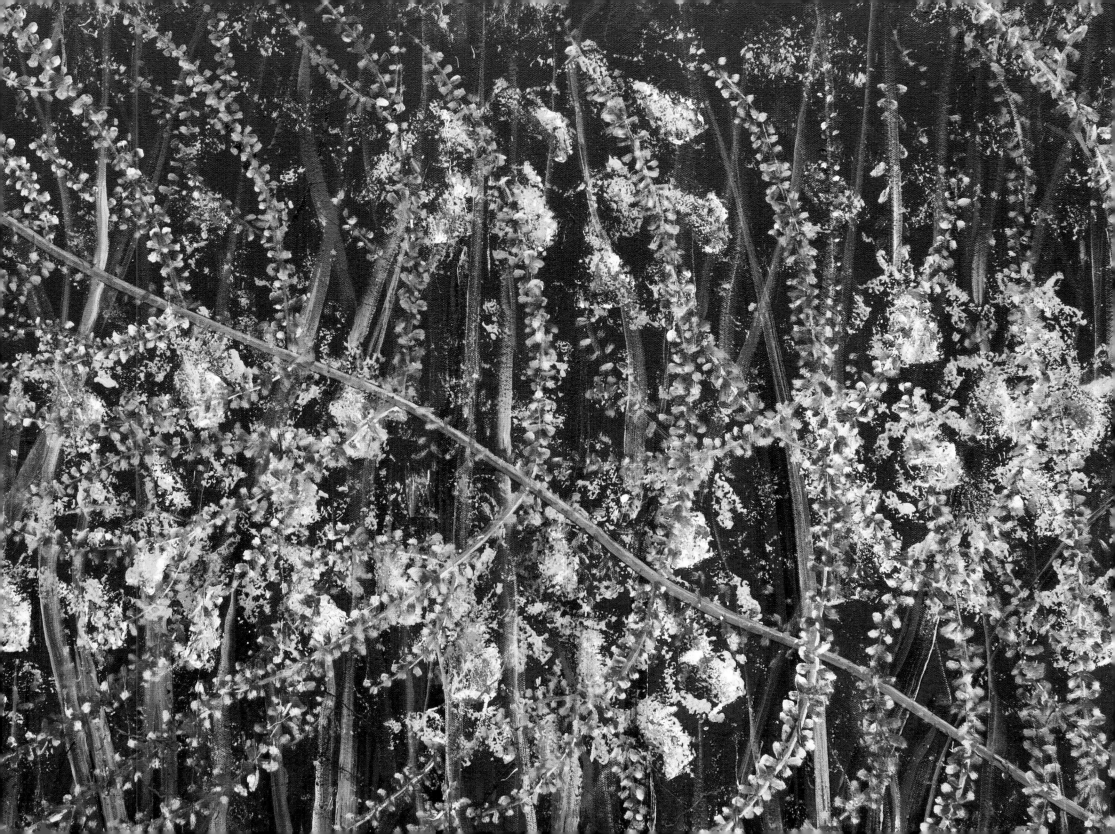

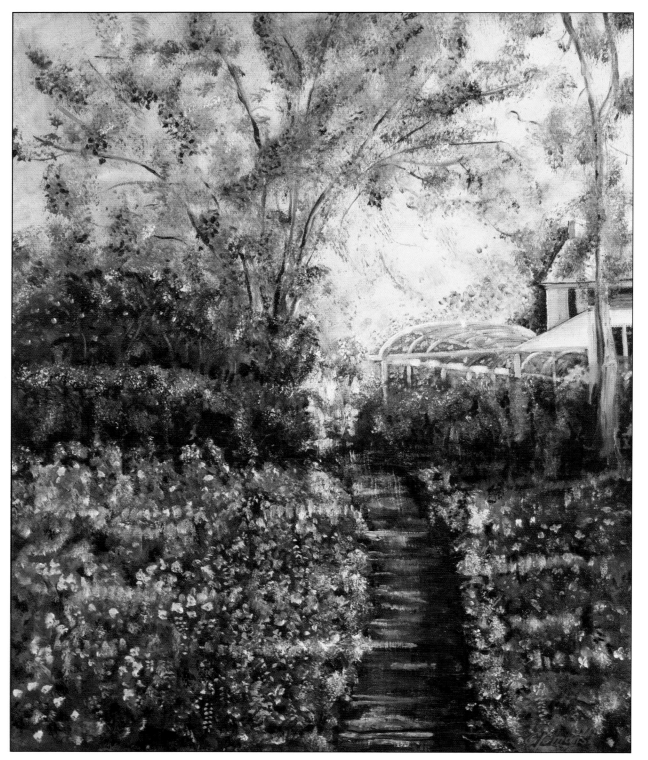

Veranda to Garden Room

It was an evolution from an early covered porch and patio (shown in the painting to the left) to a screened veranda with arched roof and, ultimately, an all-season conservatory. Windowed and skylighted, it brings the beauty of the gardens and trees inside. It is our favorite and most-used room. This series of paintings show this space as a veranda in 1991.

Left: **Garden Path**
1991
20 x 24 oil on canvas

Opposite, clockwise from left:

Mandevilla Climb
1991
24 x 36 oil on canvas

Garden View
1991
24 x 36 oil on canvas

To The Sky
1992
24 x 36 oil on canvas

Conservatory Spring
1991
24 x 36 oil on canvas

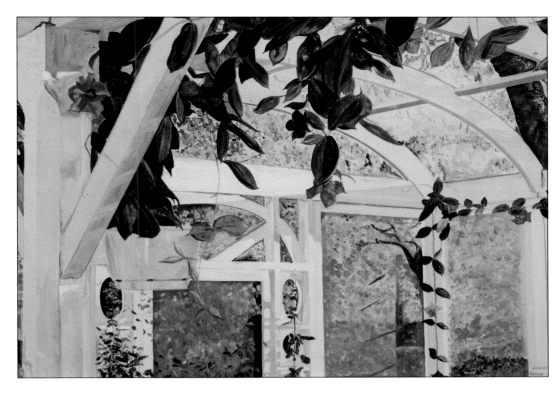

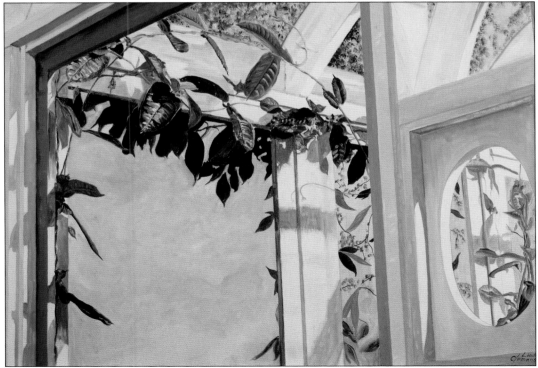

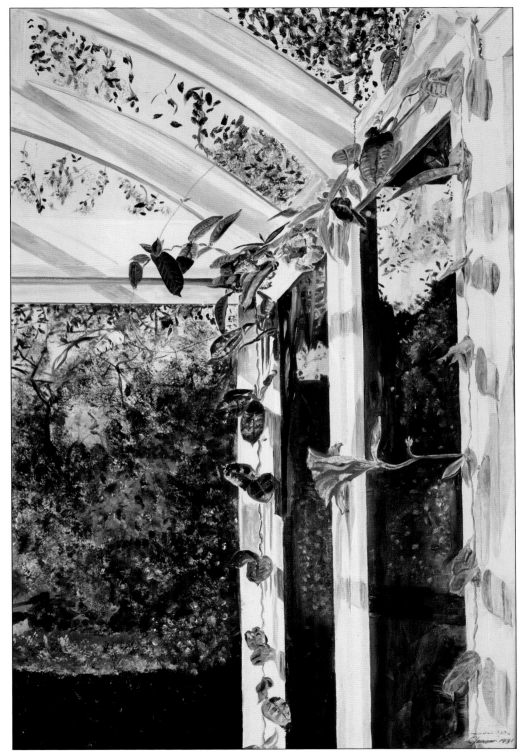

39

Peonies To Pond 2008 30 x 40 oil on canvas

The photo was shot on a sunrise winter morning. The mulberry tree glows like it's on fire. The painting was created early summer.

40

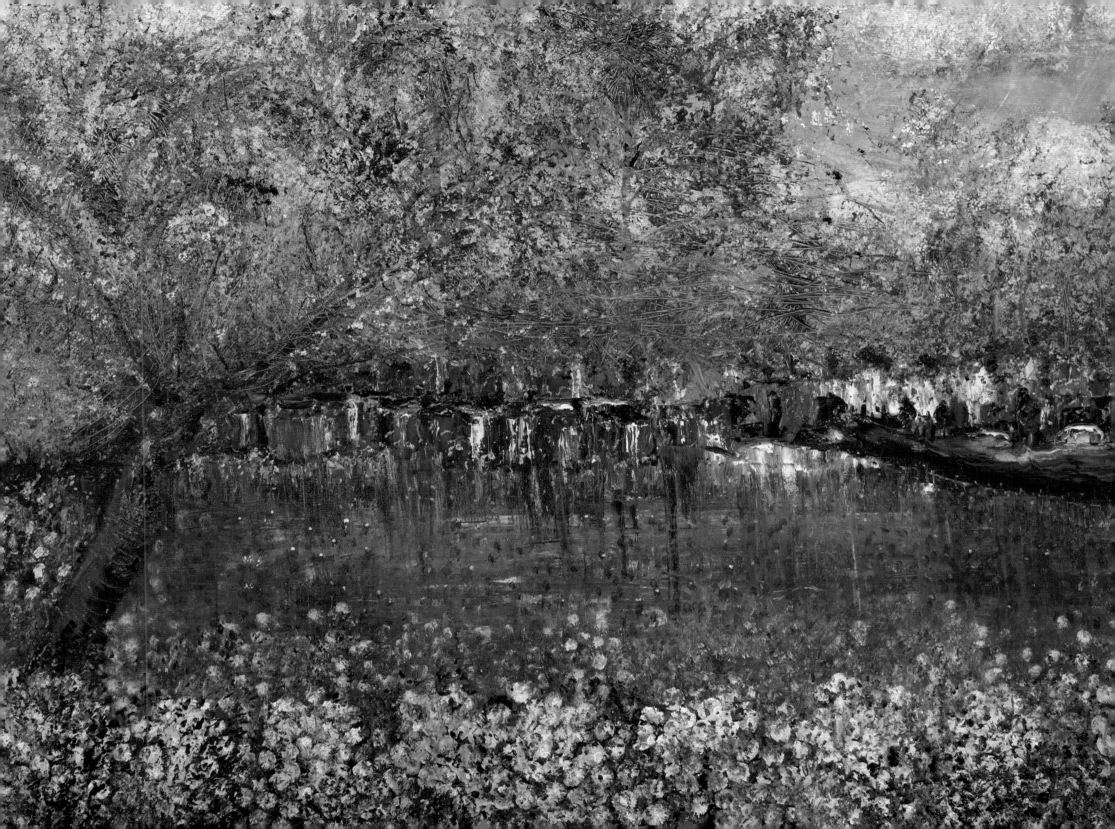

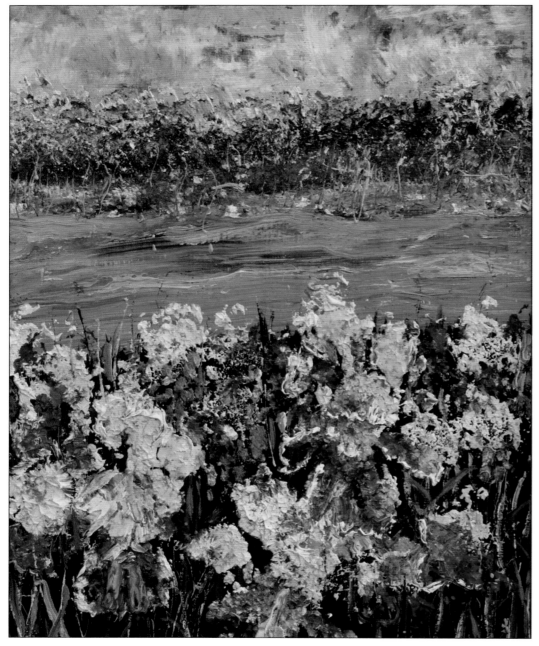

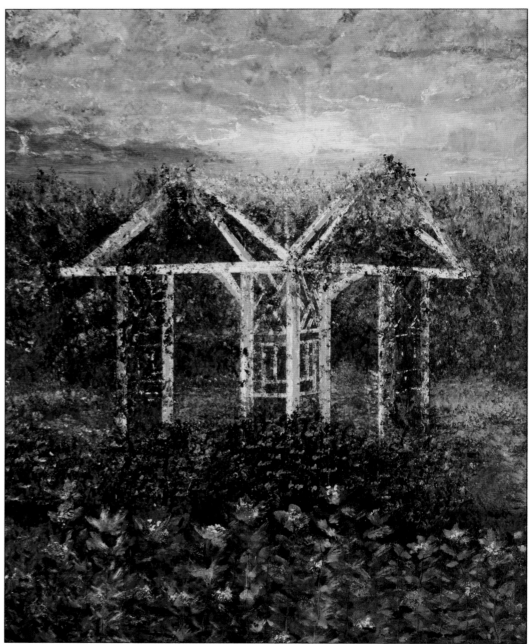

Yellow And Purple Iris 2004 8 x 10 oil on canvas

Pergola At Garden's End 2002 24 x 30 oil on canvas

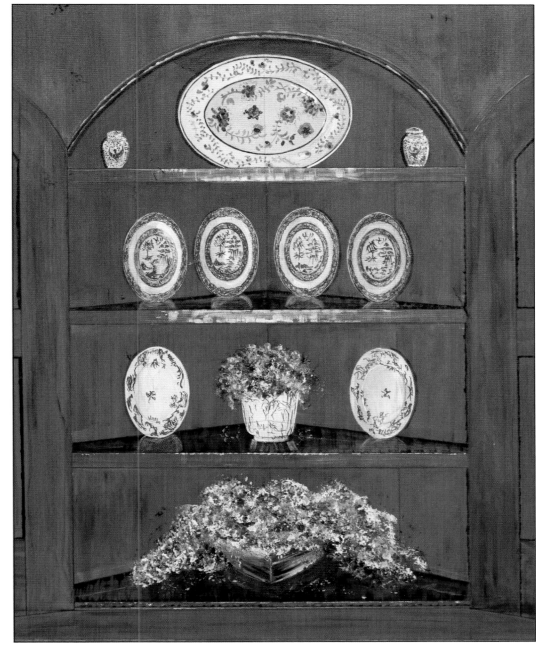

Flow Blue Corner 2006 18 x 24 oil on canvas

Twisted Olive With Lace Caps 2001 24 x 30 oil on canvas

Afternoon Delight 2006 30 x 40 oil on canvas

The purple iris and knockout roses and the vertical linearity inspired this painting.

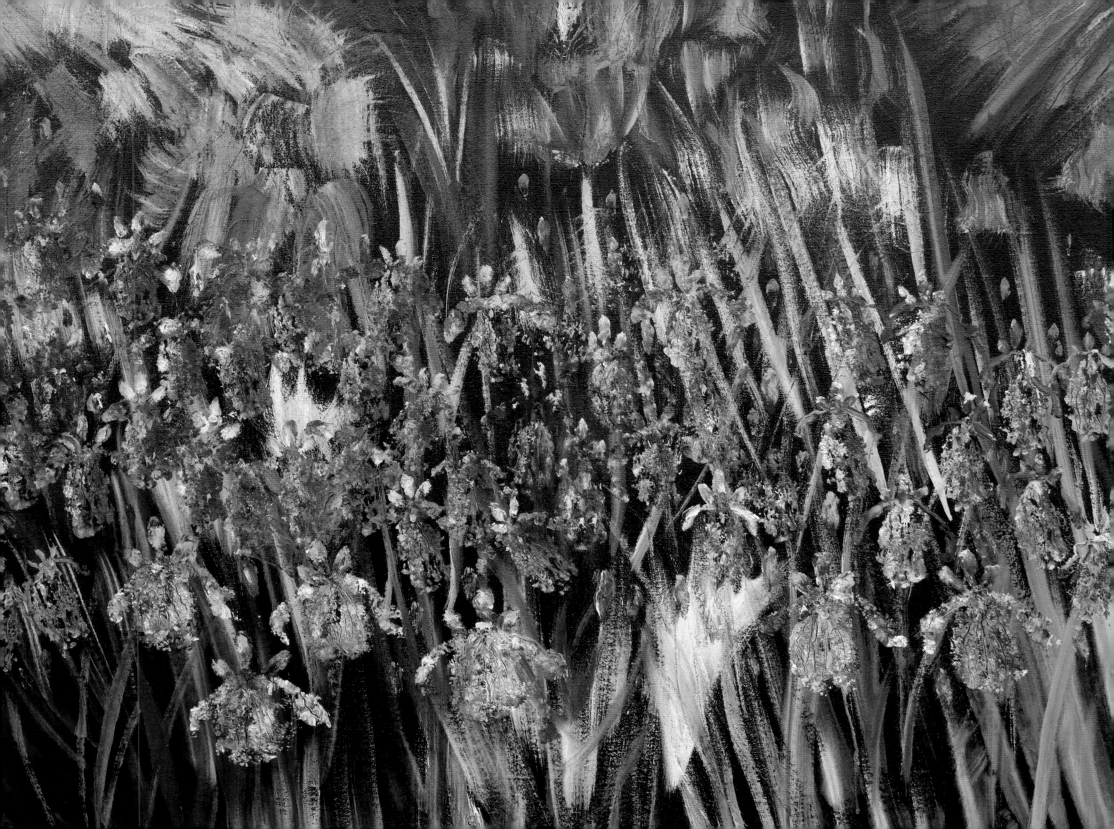

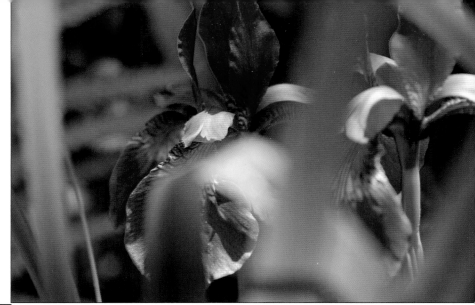

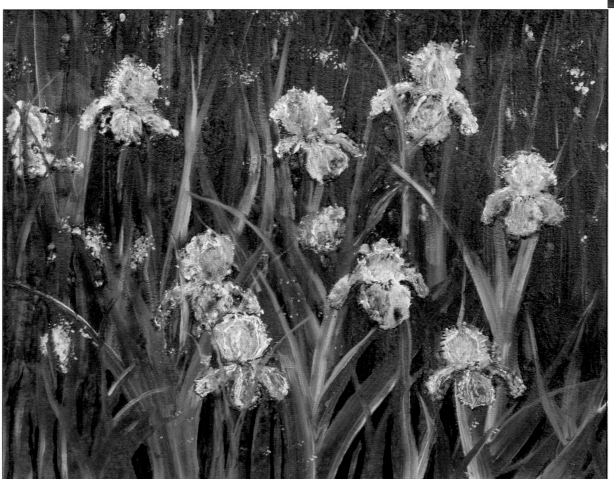

Left:
Purple Iris Afternoon
2008
19.5 x 23.5 oil on canvas

Right:
Two Iris, Intertwined
2007
12 x 16 oil on canvas
I painted this as a wedding gift for
Victor and Alicia Grasso, who were
married in Cape May in October, 2007.

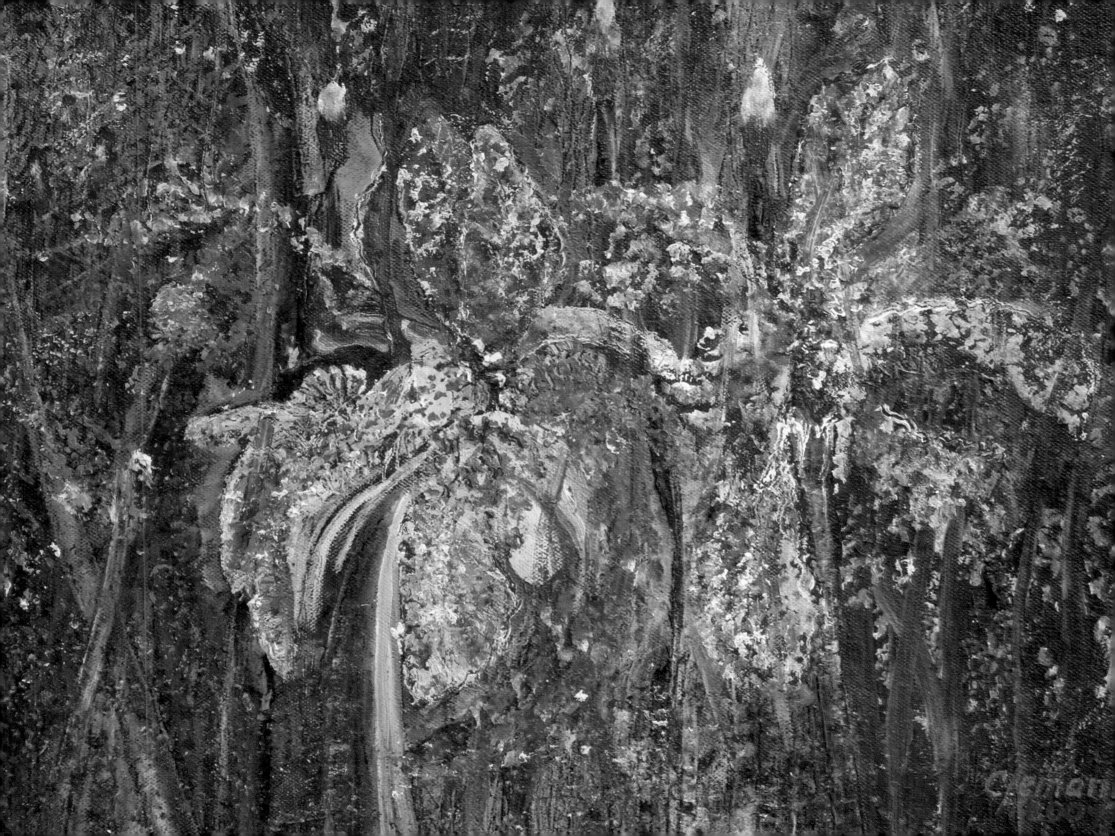

Fourth Of July
2007
8 x 10 oil on canvas

Pears Flambé
2002
11 x 14 oil on canvas

Opposite page:
Antique Pink Climber
1998
12 x 16 oil on canvas

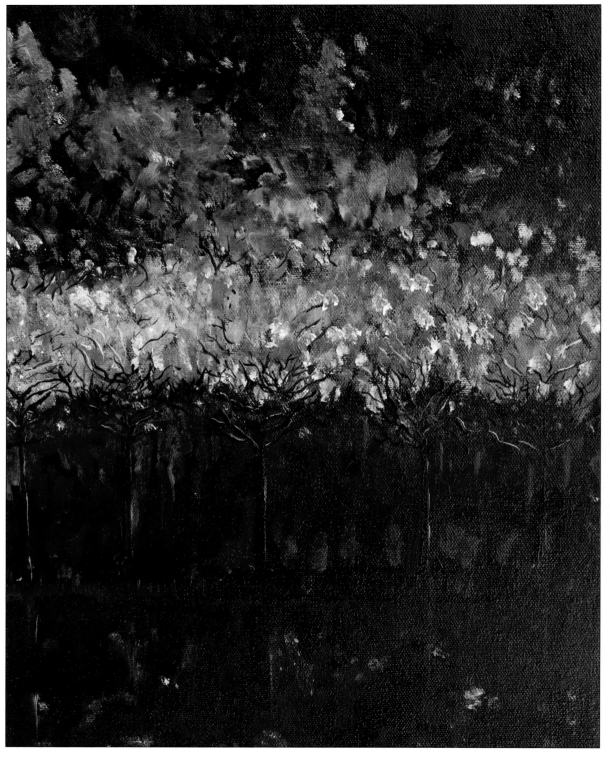

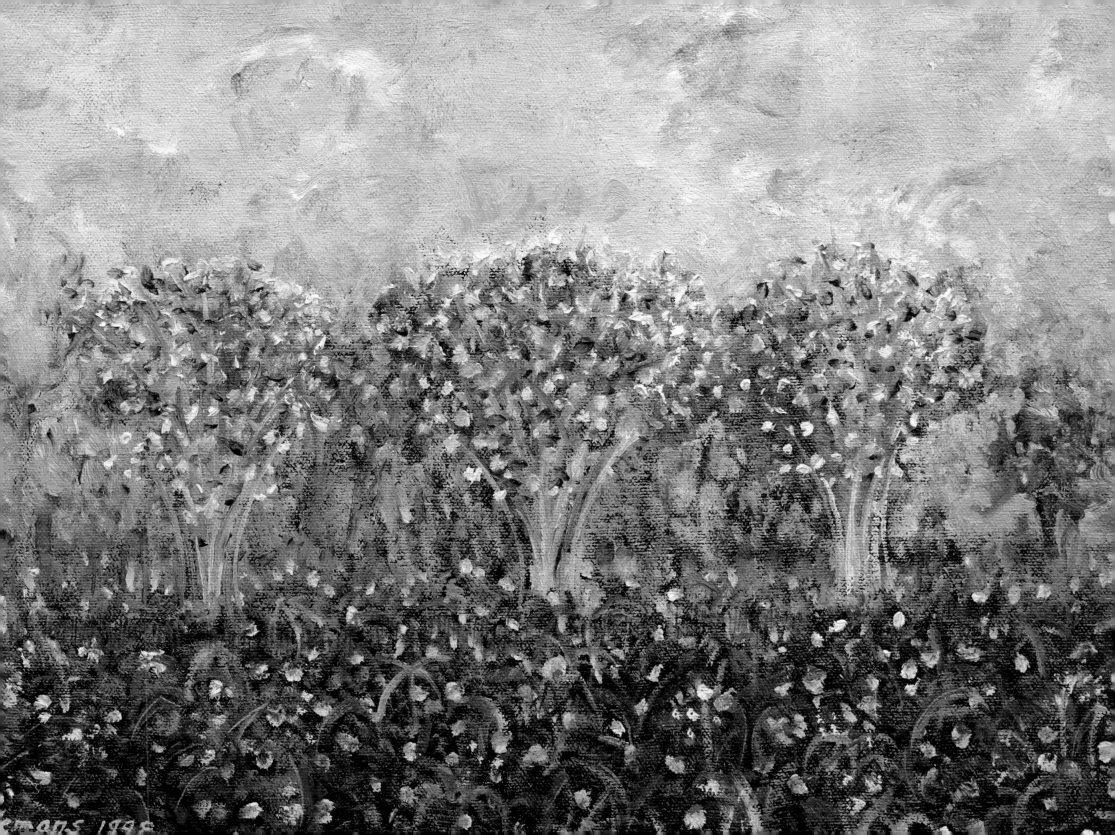

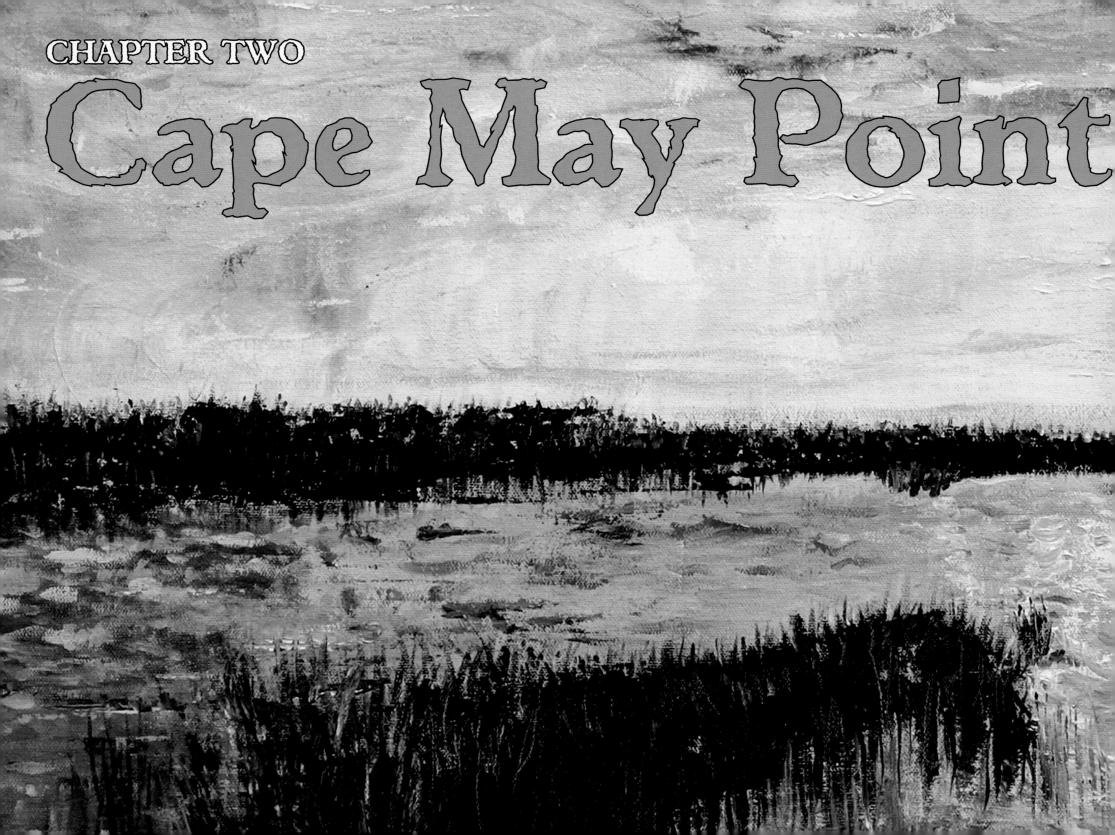

CHAPTER TWO
Cape May Point

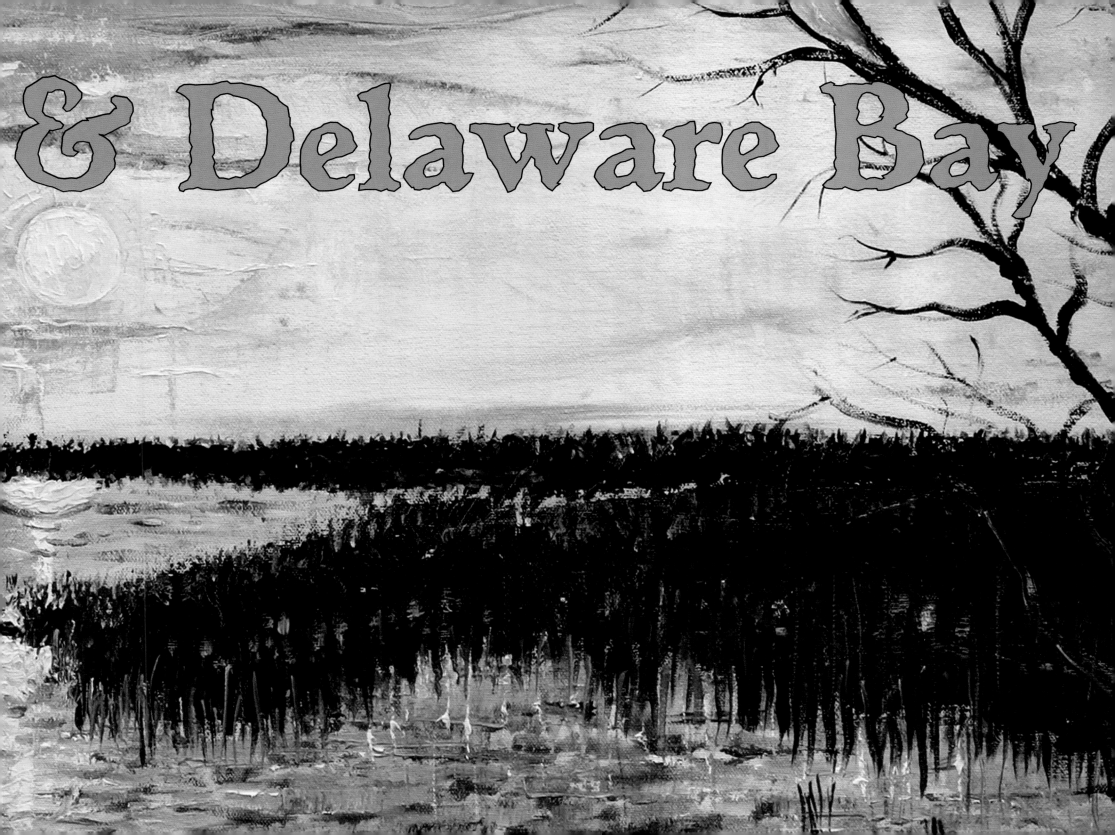

& Delaware Bay

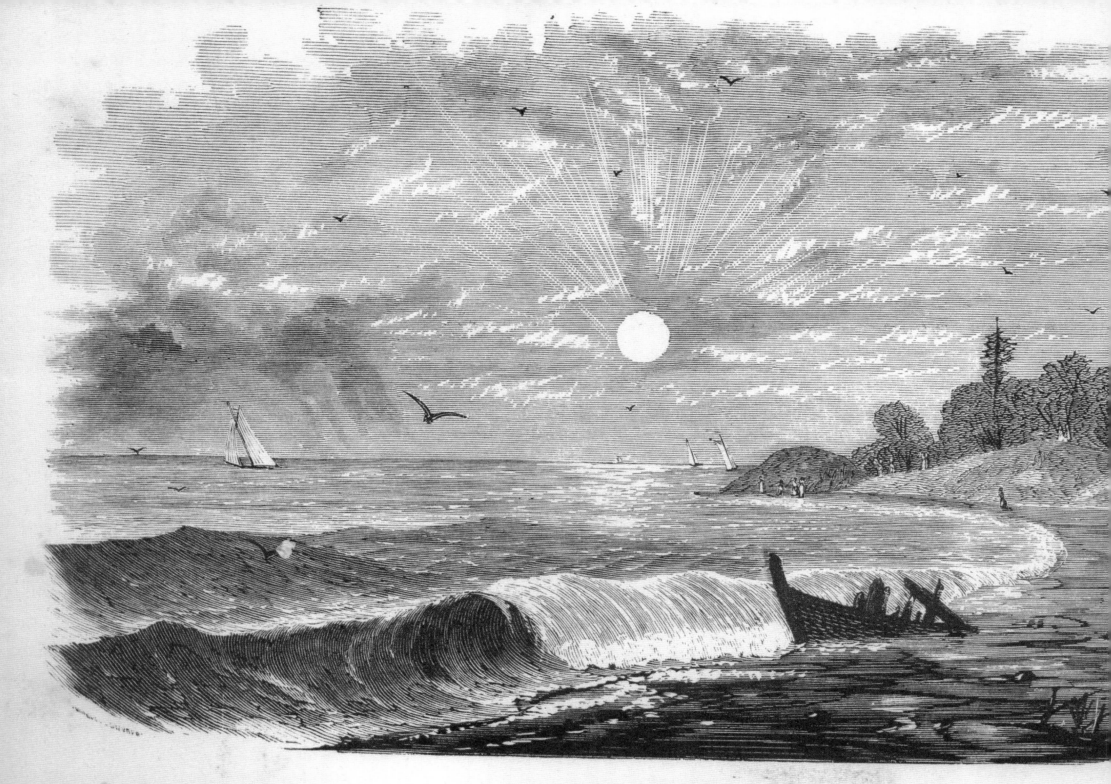

SUNSET AT SEA GROVE, 1776.

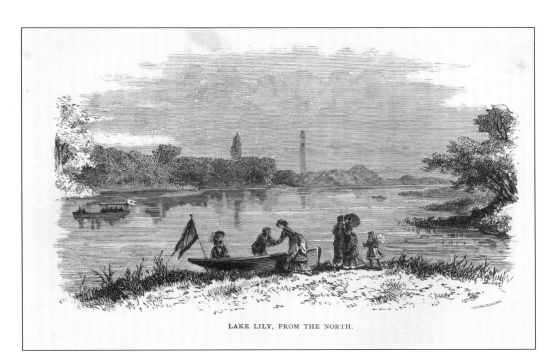

LAKE LILY, FROM THE NORTH.

Engravings of Sea Grove

In 1876 Edward S. Wheeler wrote *Scheyichbi And The Strand Or Early Days Along The Delaware With An Account Of Recent Events At Sea Grove*. The book also contained 12 engravings, from original drawings of scenes of Sea Grove, contemporaneous with its creation. Two of these are reproduced here, together with interpretive paintings by the artist.

Cape May Point and the Delaware Bay

Before 1875, Sea Grove (now Cape May Point) did not exist except as an idea hatched by Alexander Whilldin and others with whom he shared a clear vision, which was, "To furnish a moral and religious seaside home for the glory of God and the welfare of man." Today, the roads and the lots at Cape May Point remain as laid out in the original plan for Sea Grove, including the center circle, which once contained an expansive pavilion. Lake Lily, which was considerably more lush at that time, provided boating, fishing and strolling on a rustic footbridge surrounded by beautiful water lillies. The bayshore, beginning at Cape May Point and extending north past Sunset Beach, Higbee Beach and up to Del Haven, provides diverse and spectacular views. The wildness of Higbee Beach is particularly interesting to me as an artist. The vastness of the Delaware Bay helps create the most spectacular sunsets, with its refractive and reflective properties giving clouds unique color and texture.

53

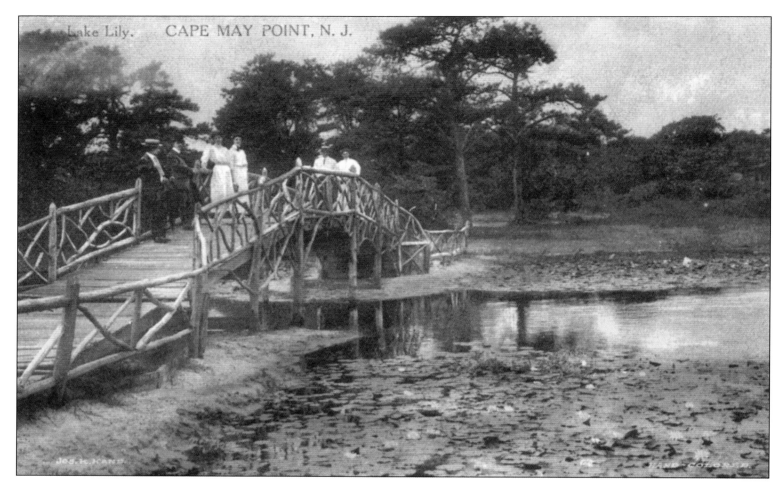

Rustic Footbridge Over Lake Lily

1995

16 x 20 oil on canvas

An old postcard showing the rustic footbridge on Lake Lily circa 1876, combined with my fascination for Monet's paintings of water lilies, gave life to this painting. My dream would be to see Lake Lily returned to this state of chromatic beauty in my lifetime. *Postcard courtesy of Don Pocher*

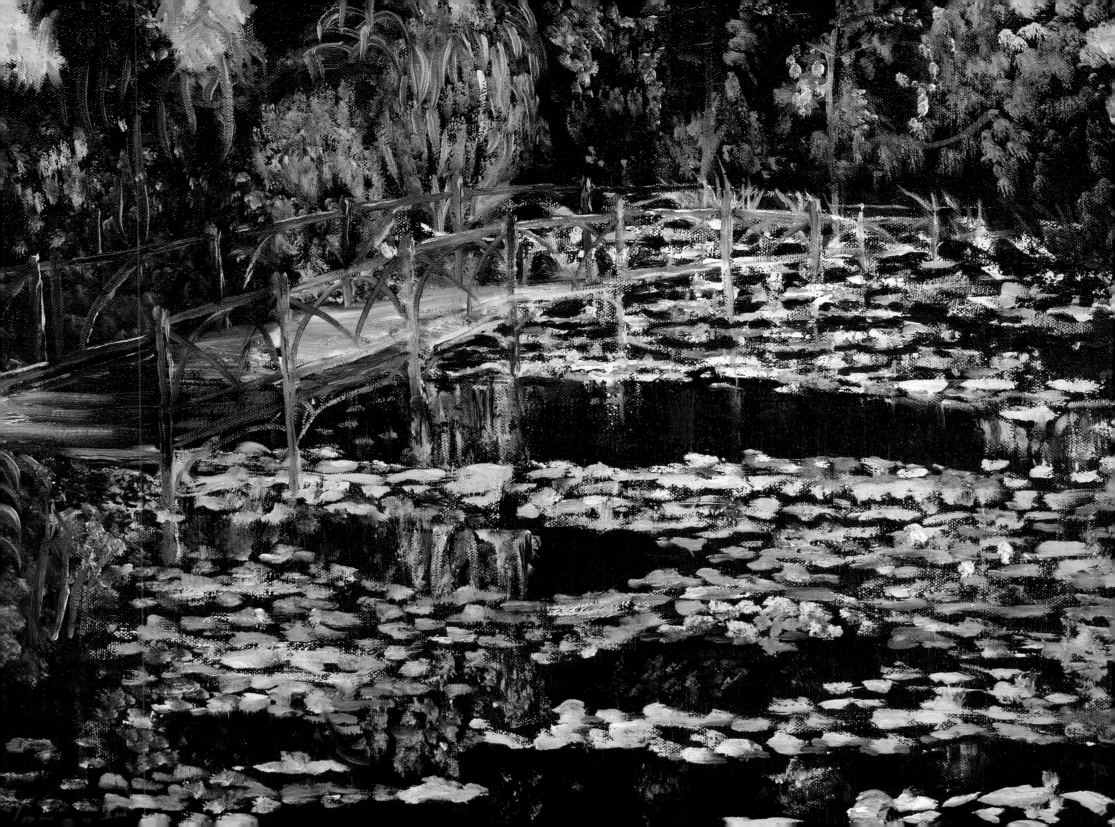

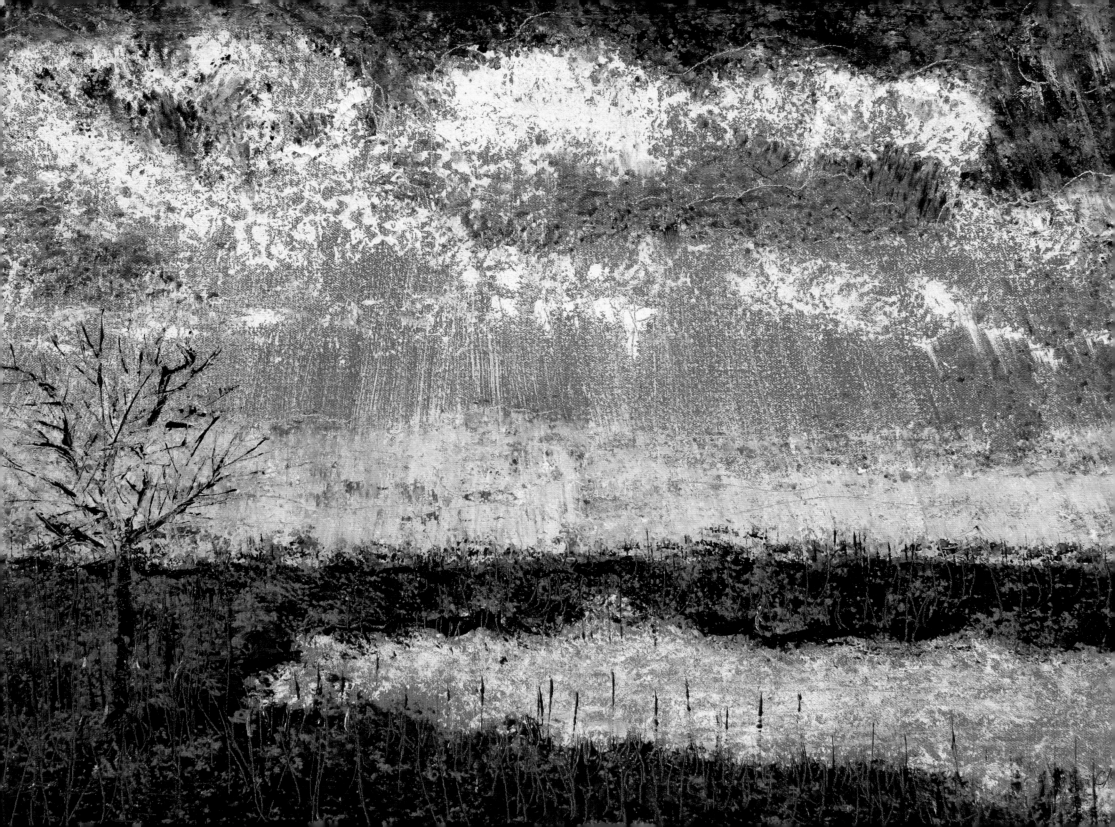

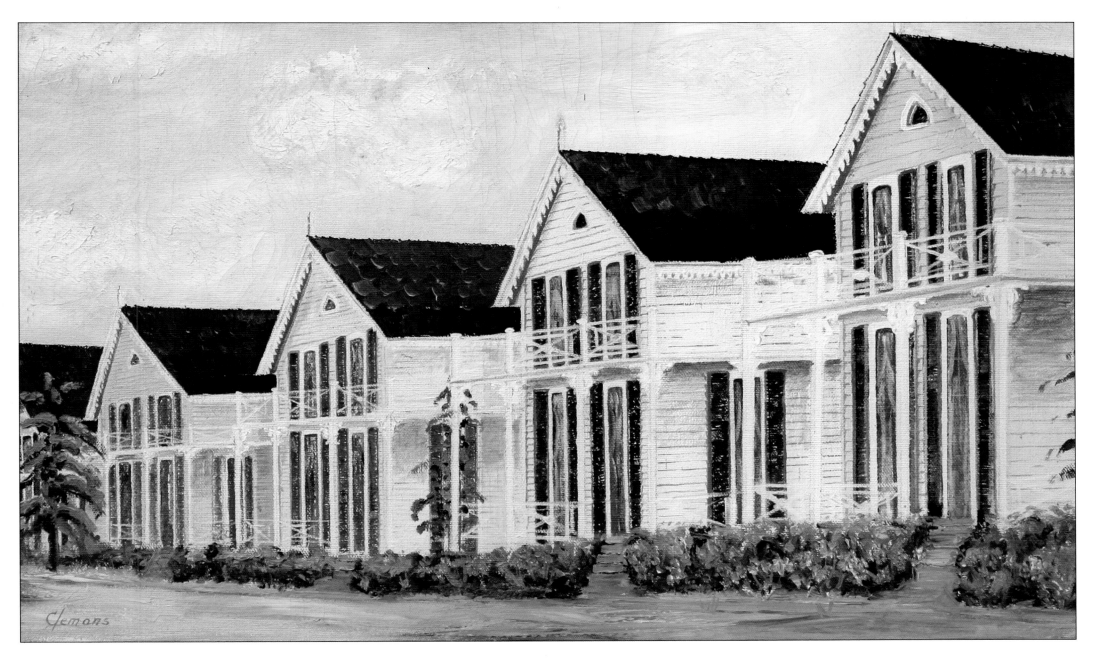

Storm Over Lily Lake

2004

18 x 24 oil on canvas

Five Sisters

1980

12 x 20 oil on canvas

Cottages on Lincoln Avenue in
Cape May Point, re-imagined.

Lake View
2001
12 x 16 oil on canvas

Beach Pavilion – Sea Grove 1876
2008
11 x 14 oil on canvas

Wedding gift to Kirsten Moffatt
and Jeffrey Kreiss, who were married
in Cape May on April 12, 2008.

Lily Lake Dredge
2004
8 x 10 oil on canvas

Opposite page:
Lily Lake To Lighthouse
2008
11 x 14 oil on canvas

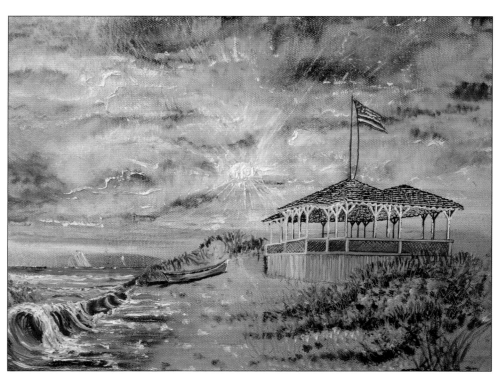

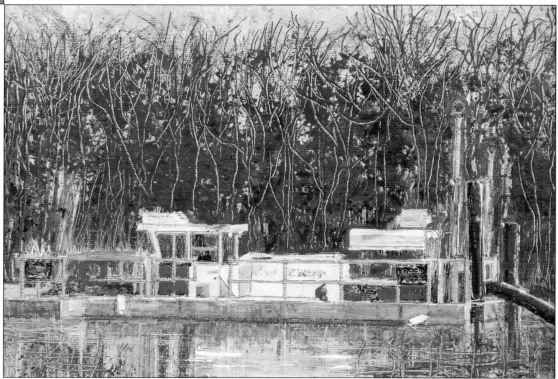

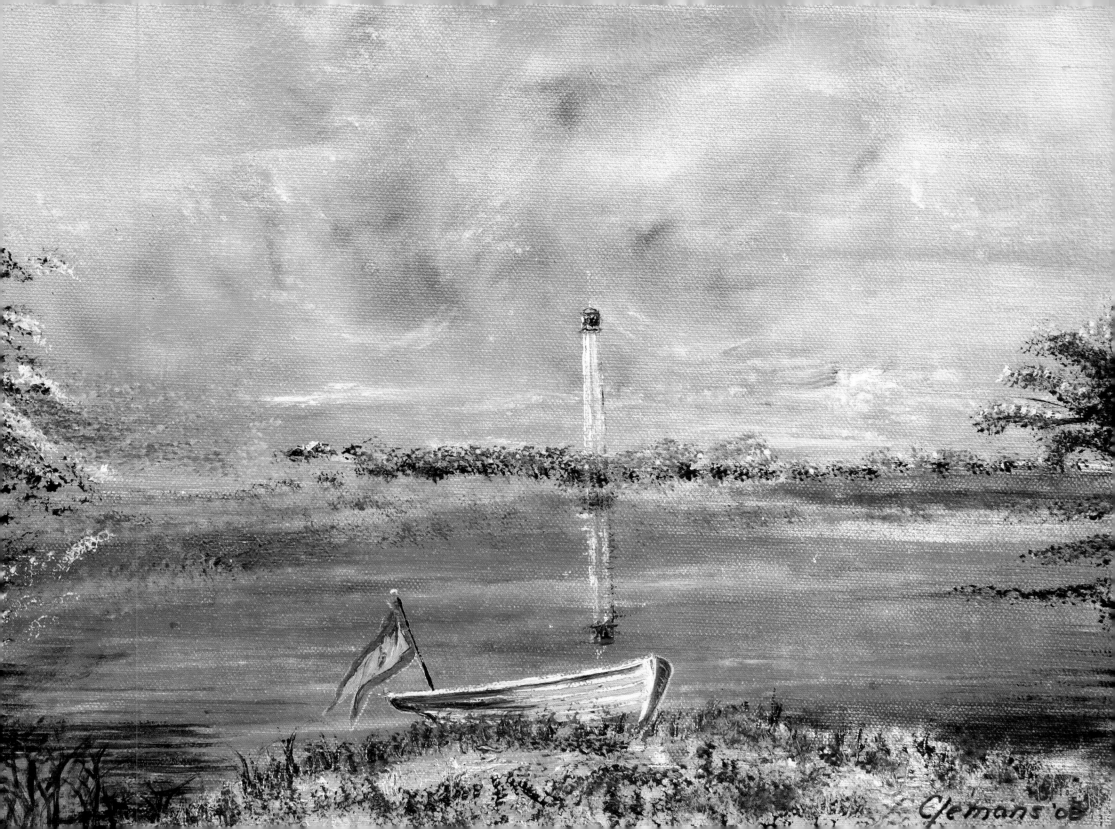

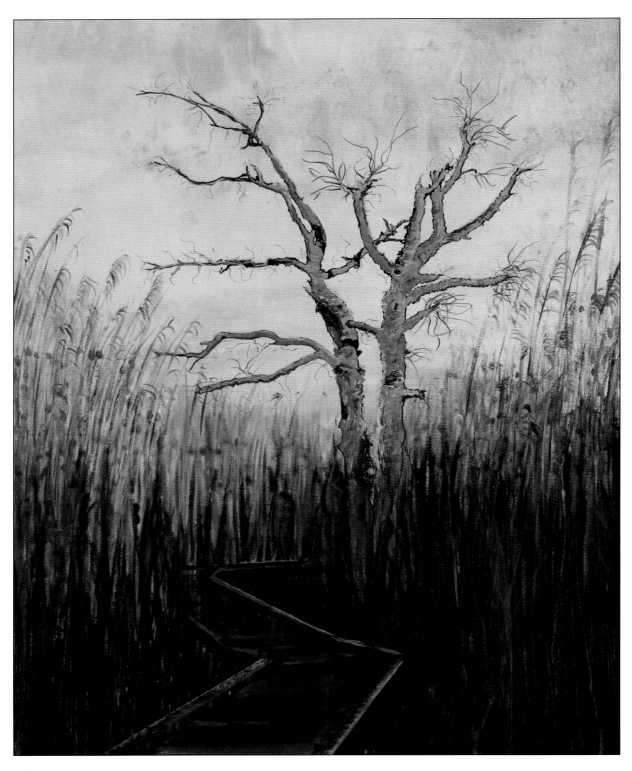

Trail Blazing
2008
16 x 20 oil on canvas
I would not have thought that a tree long dead could be resurrected by the afternoon sun as a blaze of beauty, but here it was along a nature trail in Cape May Point State Park.

Opposite page:
Flora Dune
1980
8 x 10 oil on canvas

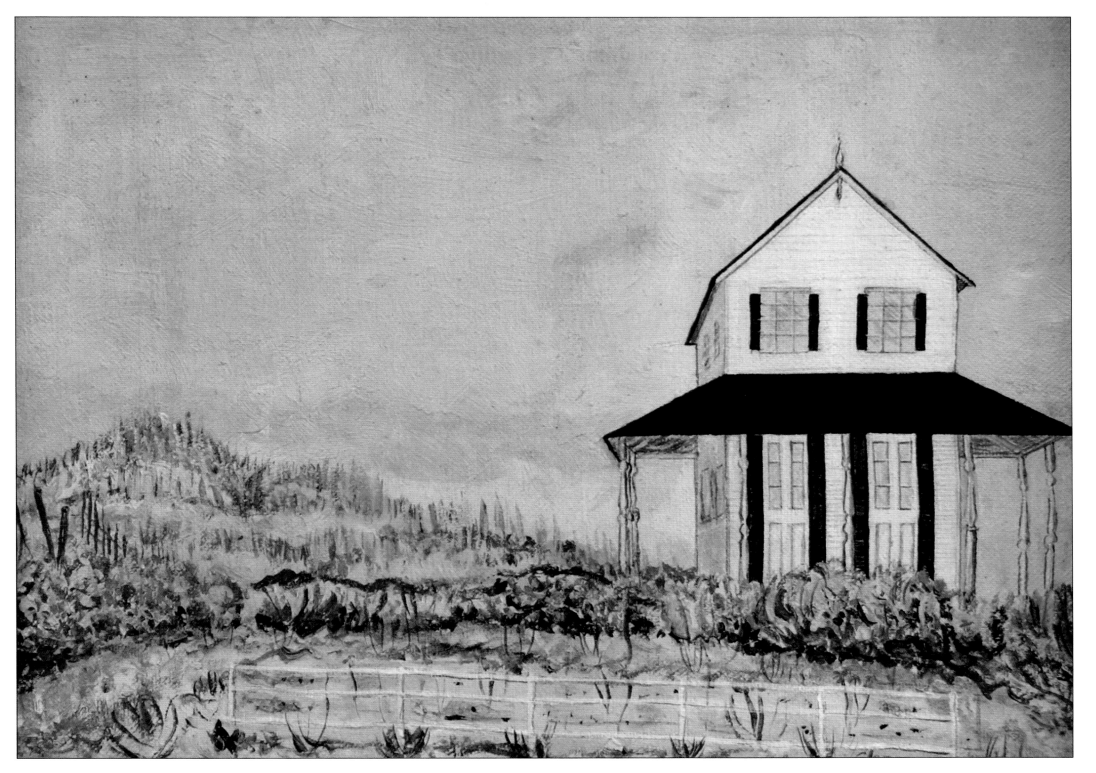

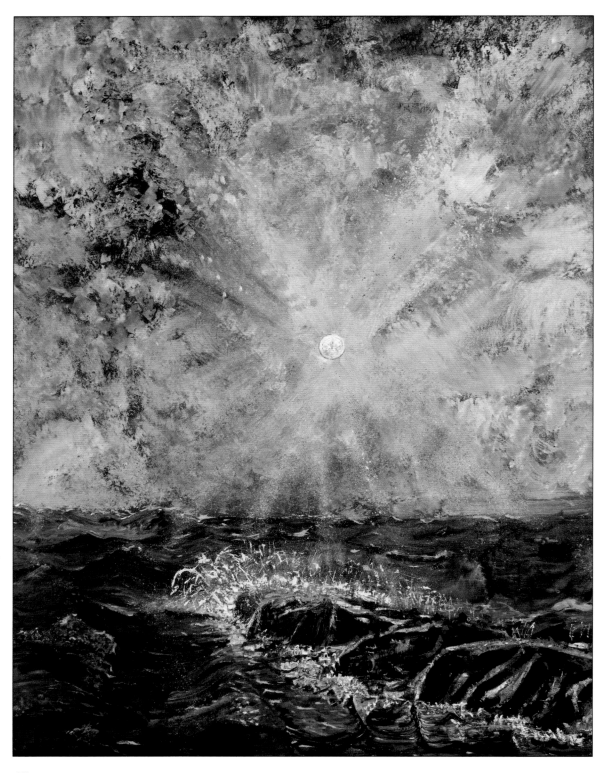

Jetty Sunset
2000
30 x 40 oil on canvas

I mentioned the incomparable
sunsets over the Delaware Bay
in my introduction to this section
of the book. This painting, done
at the Alexander Avenue jetty
in Cape May Point, perfectly
captures the cloud textures and
intense chromatic values evident
after a storm. The water breaking
over the rocks creates a fine
spray, reflecting the same colors.

Opposite page:
Sea Grove Beach Sunset
2008
11 x 14 oil on canvas

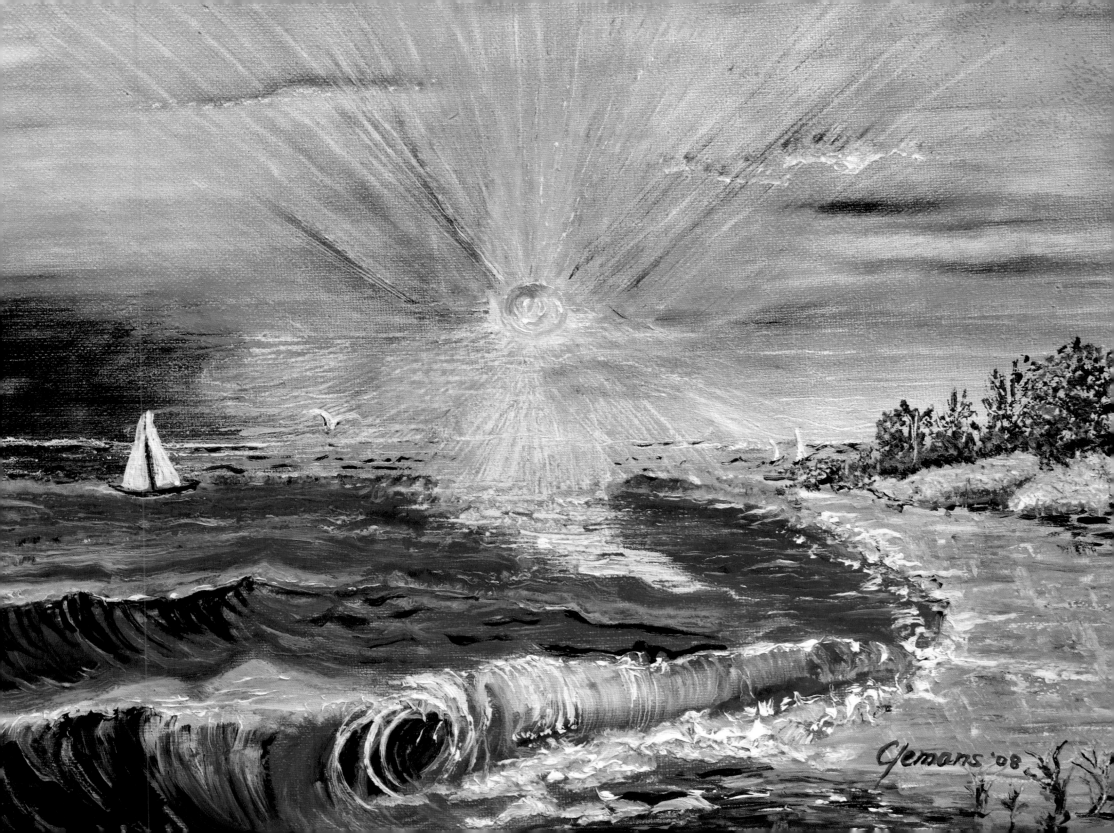

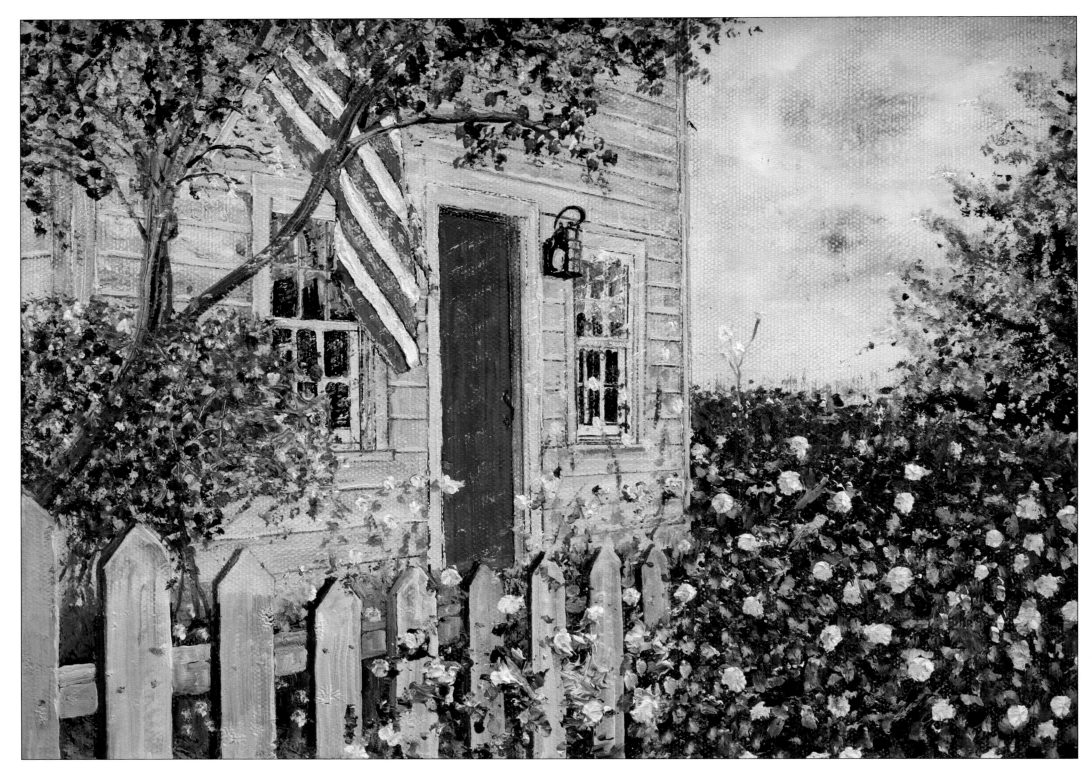

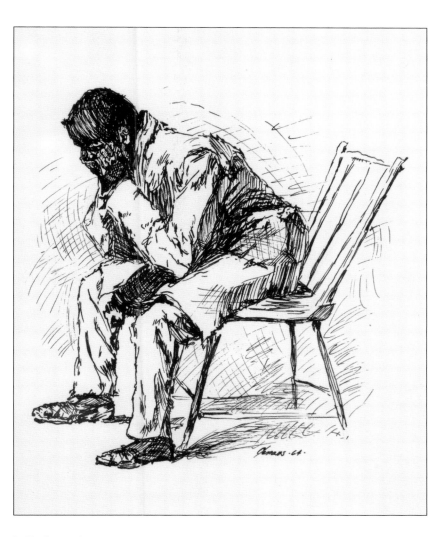

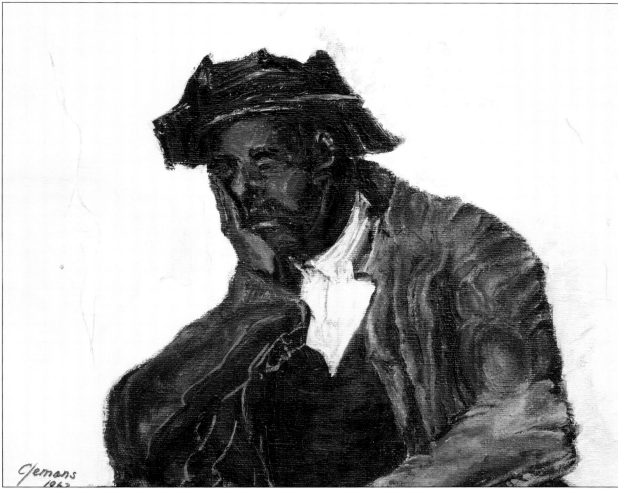

Whalers Cottage

2008

9 x 12 oil on canvas

For many years, local legend suggested that the cottages at 1017 and 1019 Batts Lane were two among a small grouping of similar buildings originally located at Town Bank on the Delaware Bay and moved inland as that body of water encroached upon them. Recent research confirms that 1019 Batts Lane very closely conforms in age, circa 1700, and simplicity of design to the descriptions of the early buildings at Town Bank. It was moved to its present location around 1846 and expanded into a two-story house by Owen Coachman, a free black farmer and descendent of slaves. The Owen Coachman House was placed on the National Register of Historic Places in 2005. In April 2006, the Owen Coachman House was awarded an historic preservation award by the State of New Jersey.

Owen Coachman Sketch *1964* 7 x 10 pen and ink **Owen Coachman Portrait** *1962* 11 x 14 oil on canvas

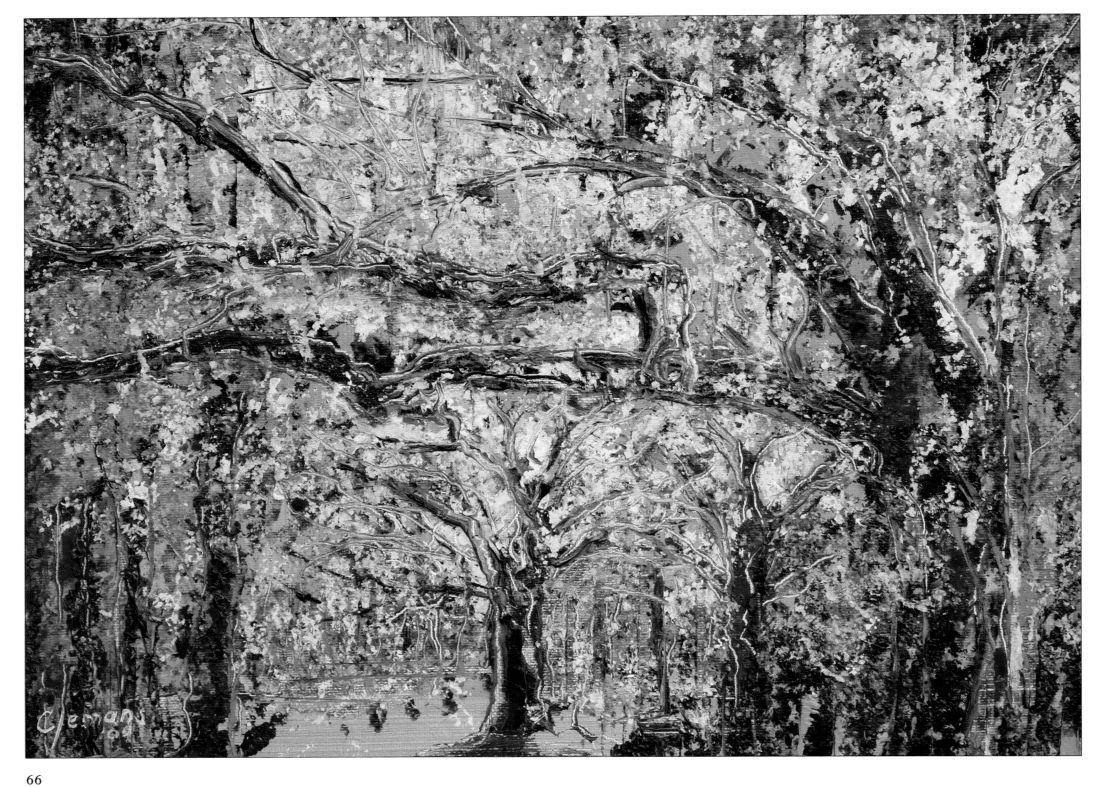

66

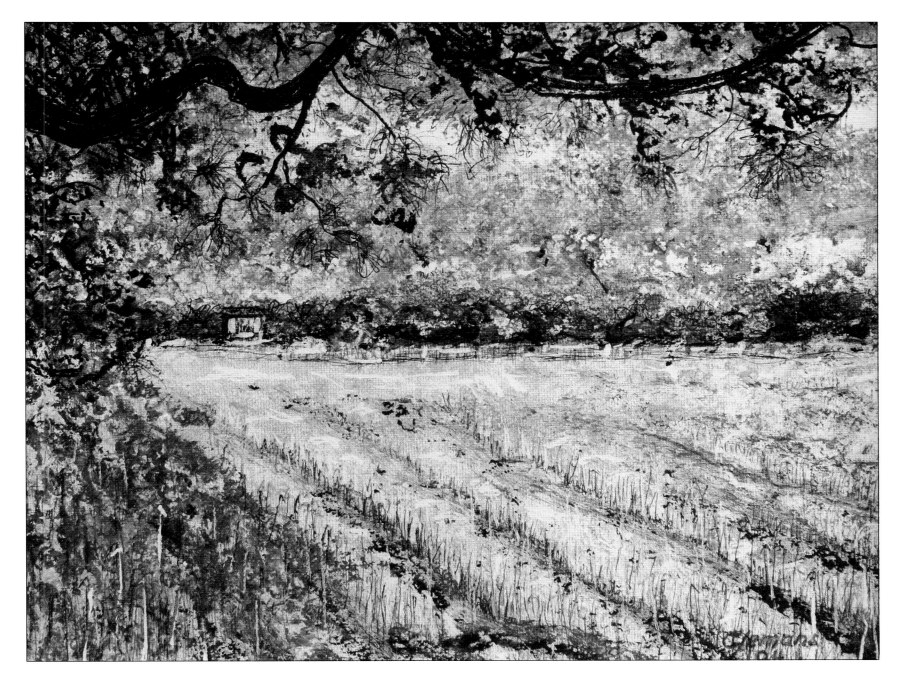

Black Cherry Orchard
2004 11 x 14 oil on canvas

Hayfield At Dusk
2004 8 x 10 oil on canvas

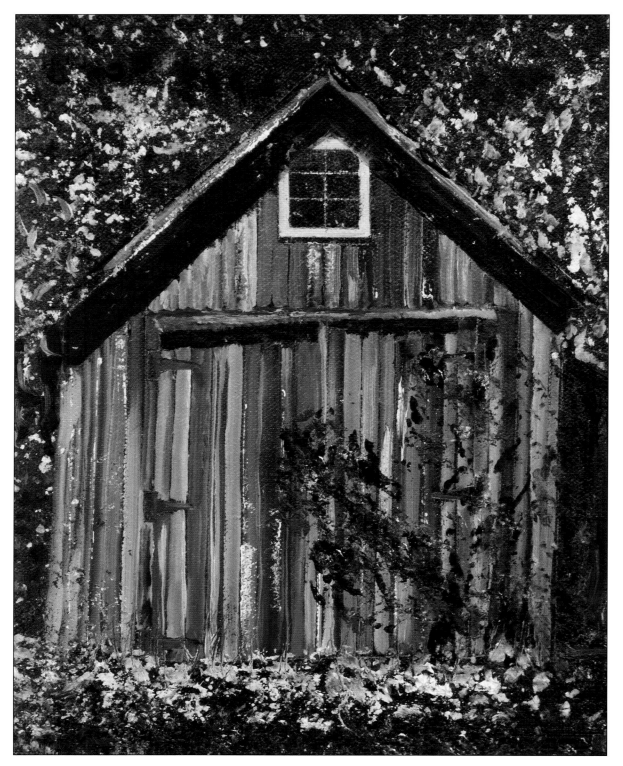

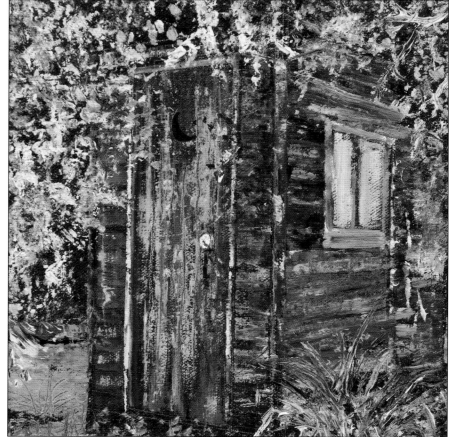

Batts Lane Barn

2004

8 x 10 oil on canvas

Batts Privy

2004

8 x 10 oil on canvas

Opposite page:

Paned Lace Caps Inside

2005

24 x 30 oil on canvas

Paned Lace Caps Outside

2005

8 x 10 oil on canvas

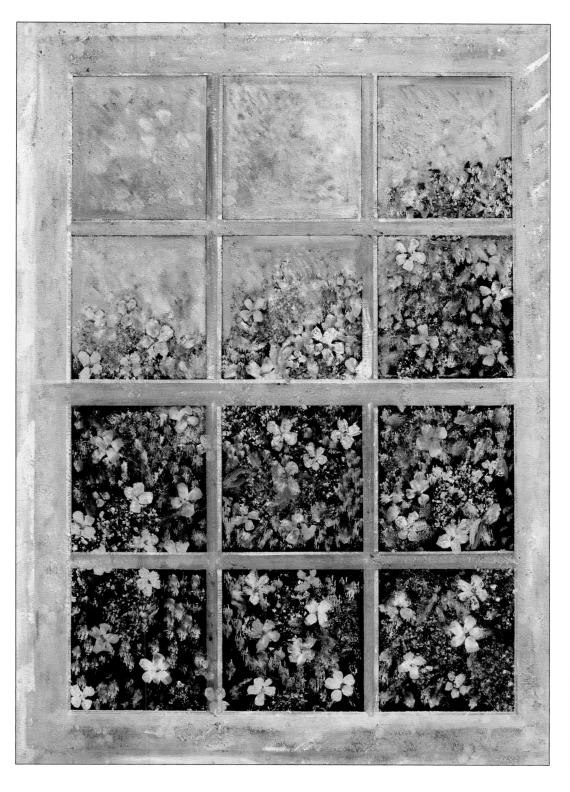
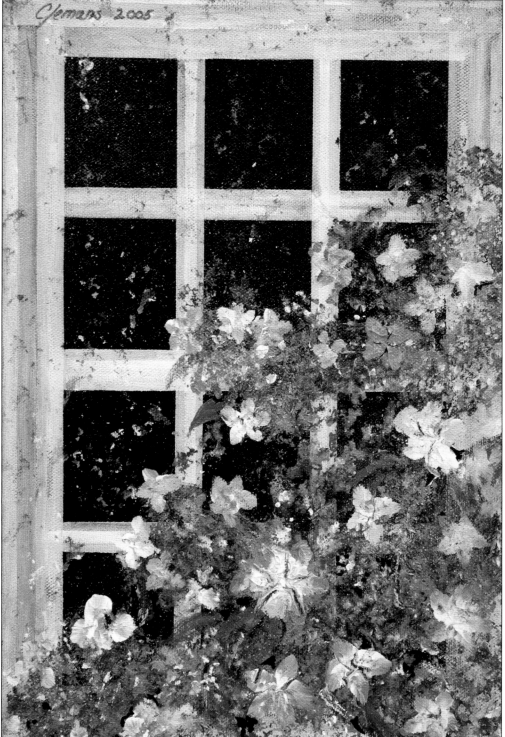

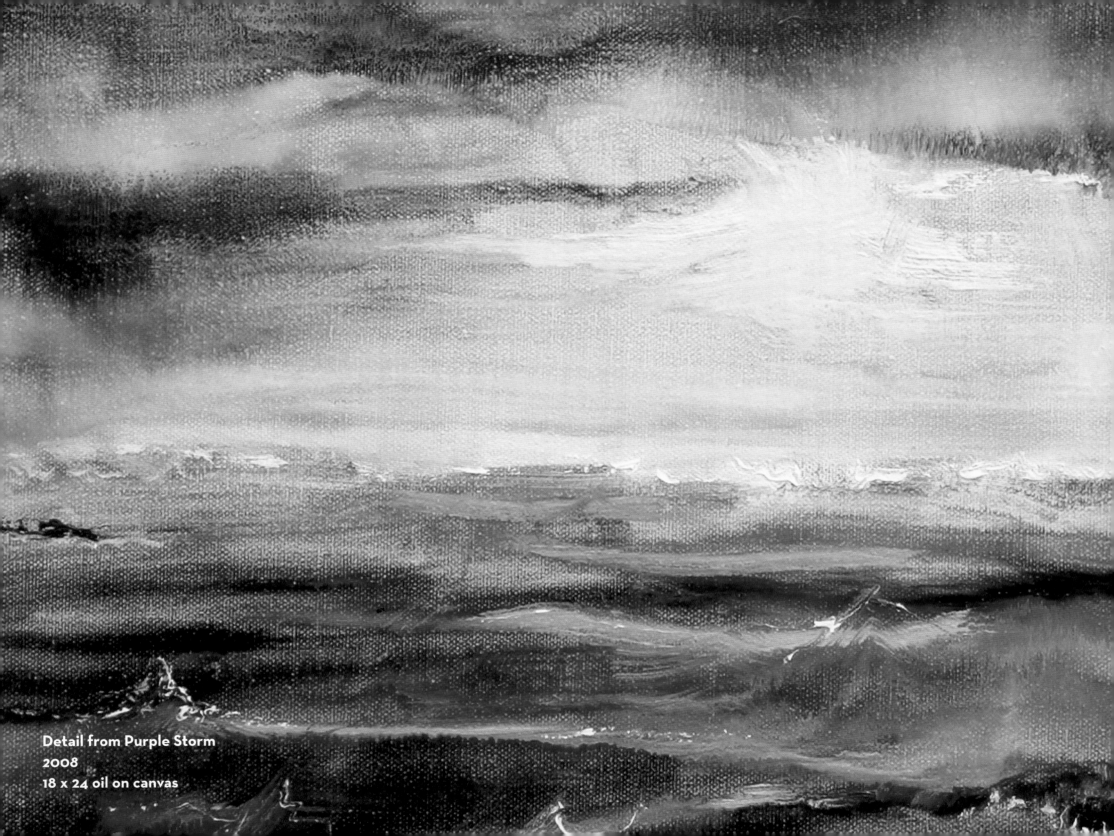

Detail from Purple Storm
2008
18 x 24 oil on canvas

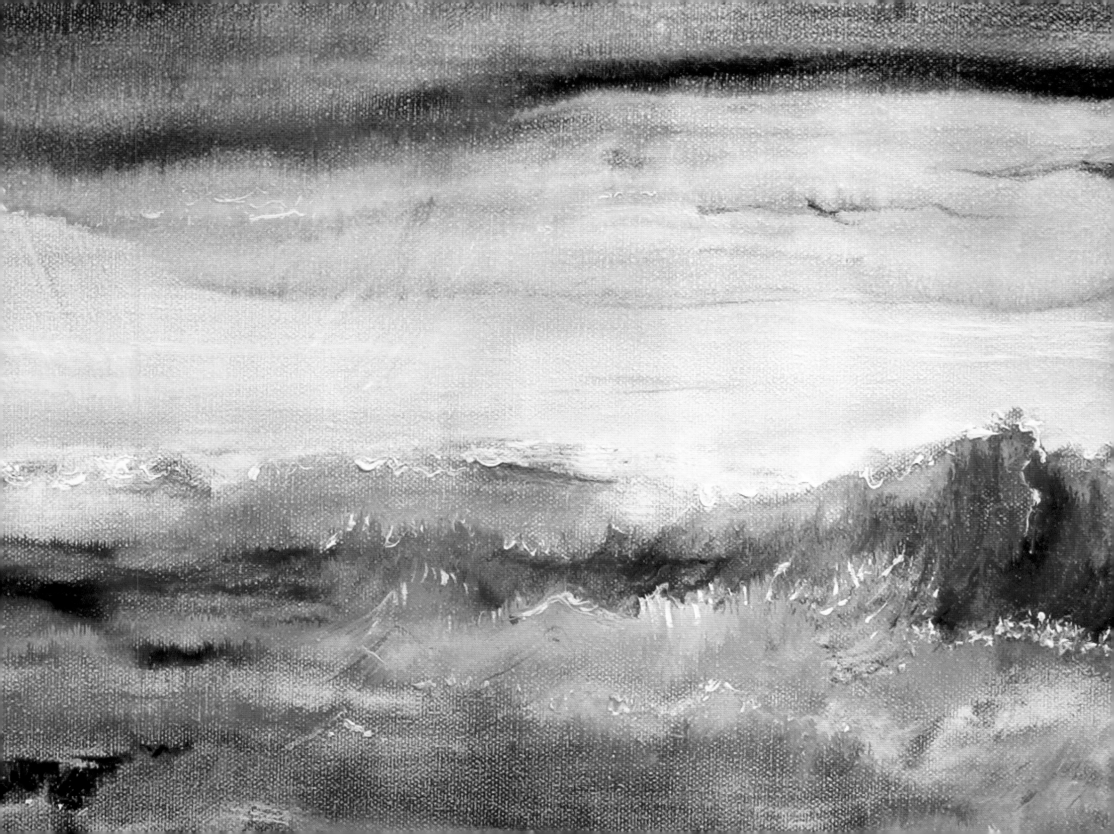

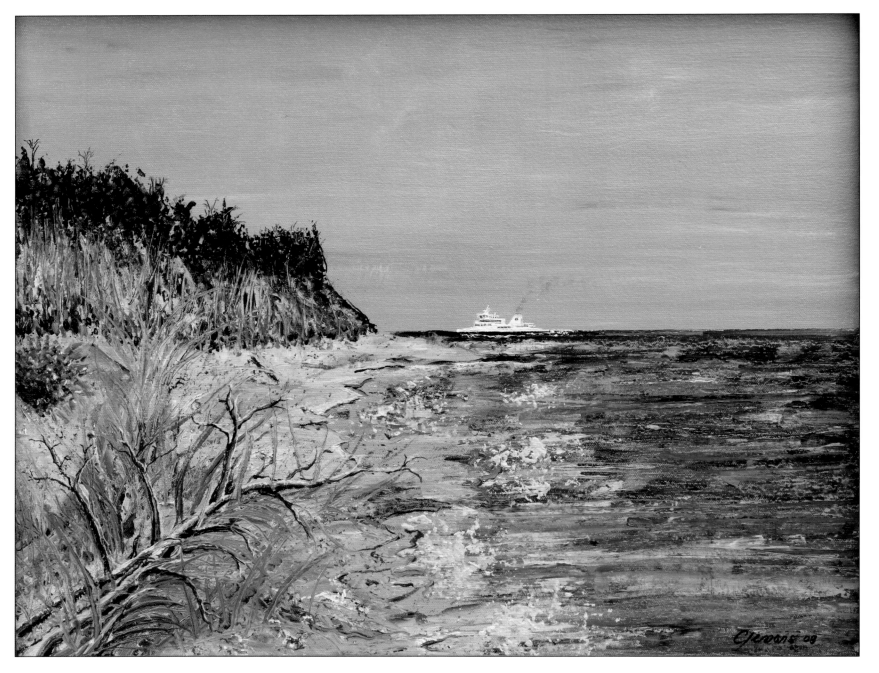

Higbee Beach
2008
16 x 20 oil on canvas

Bay Marsh Sunset
2001
24 x 36 oil on canvas

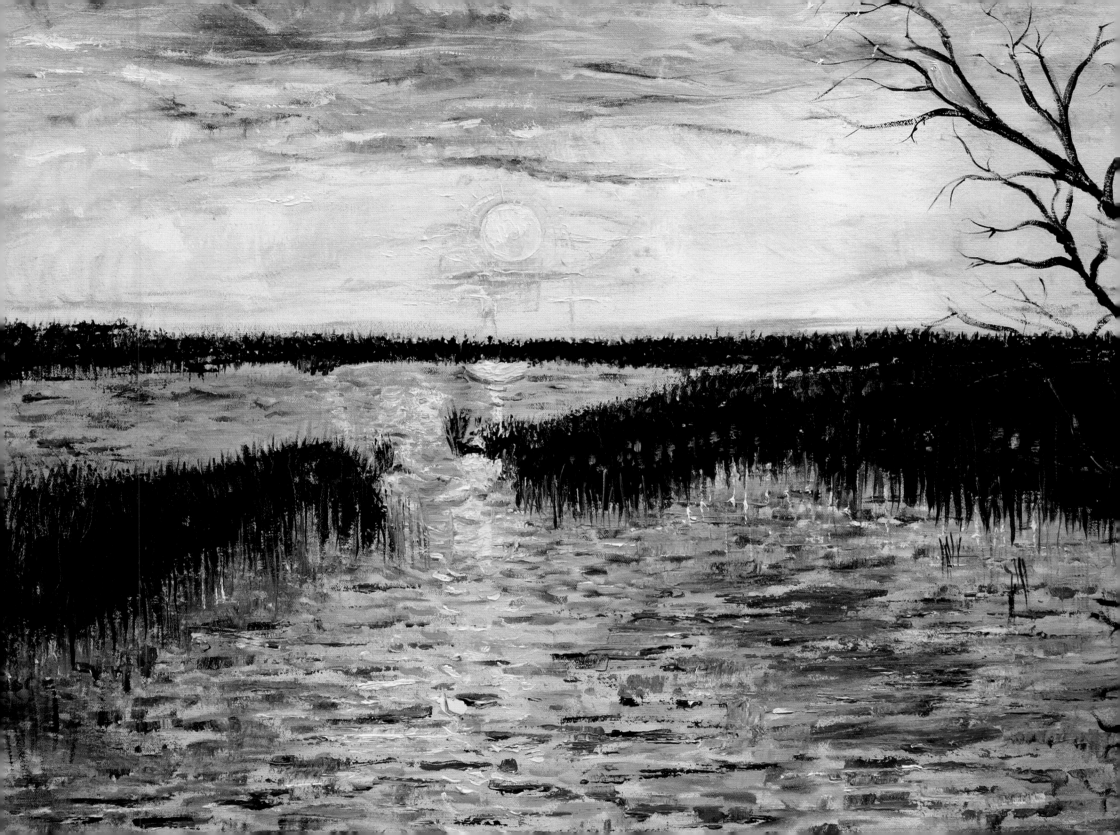

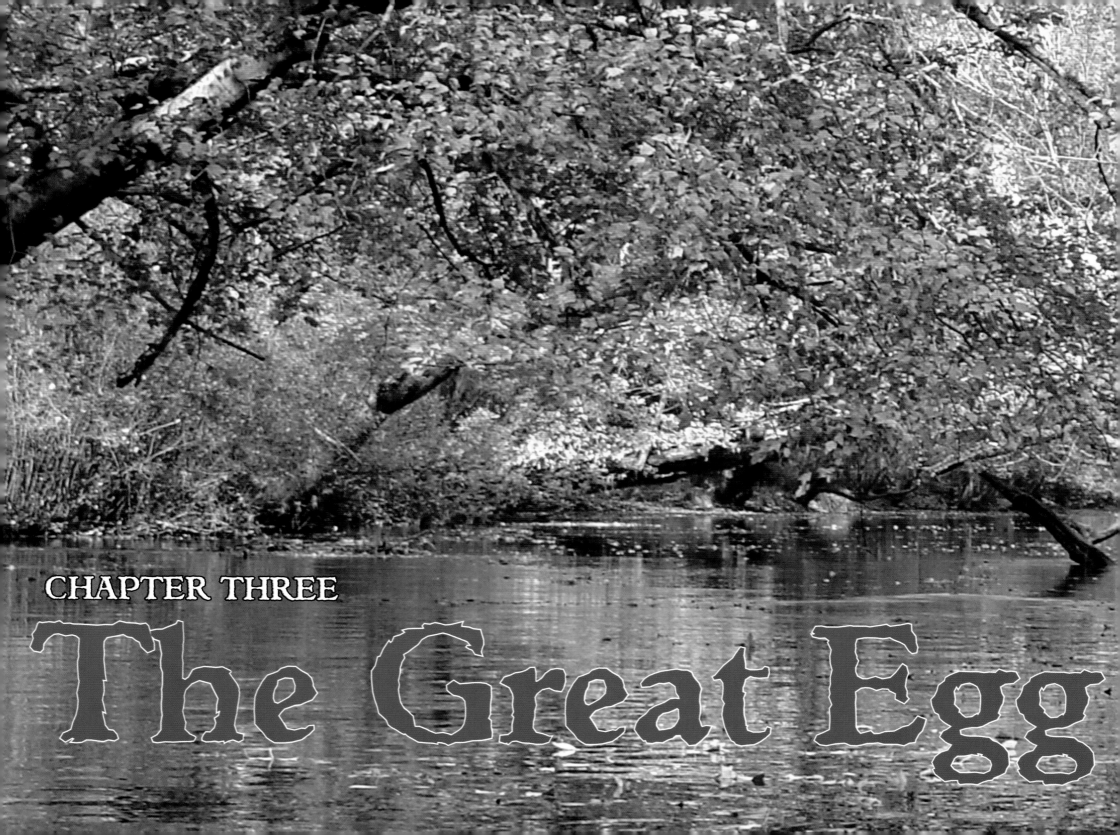

CHAPTER THREE

The Great Egg

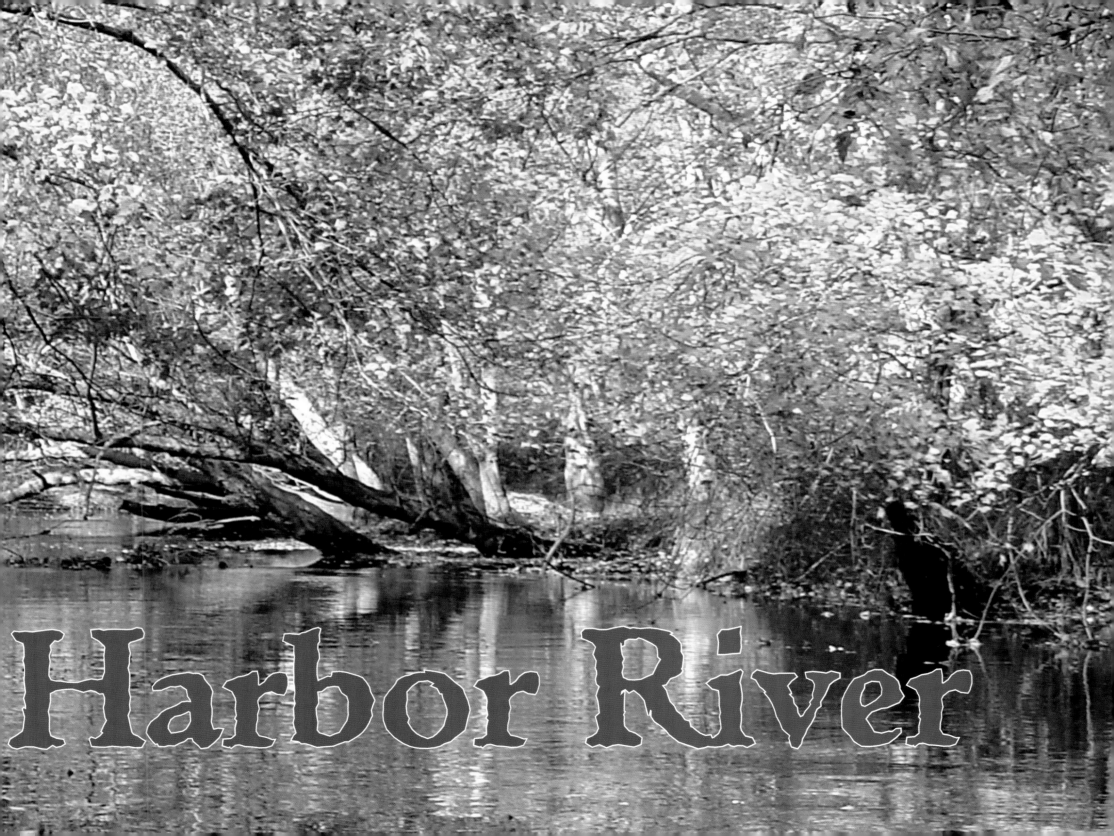

The Great Egg Harbor River

"I do not know much about gods; but I think that the river is a strong brown god – sullen, untamed and intractable."
– T.S. Eliot, excerpt from *The Dry Salvages*

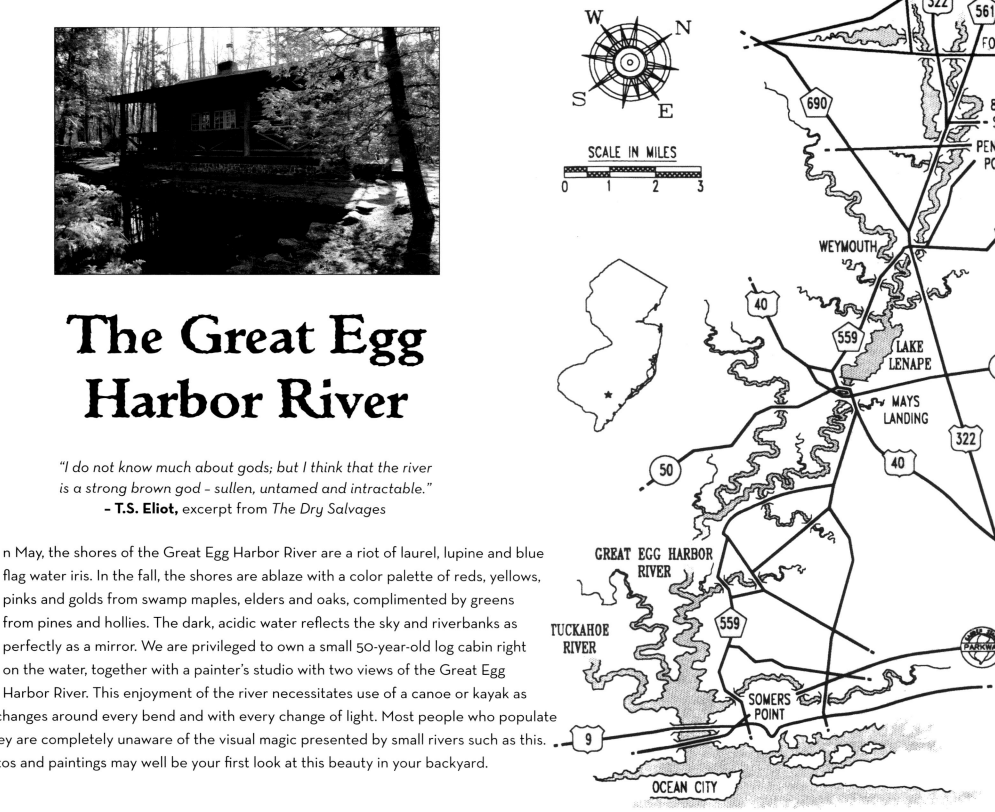

In May, the shores of the Great Egg Harbor River are a riot of laurel, lupine and blue flag water iris. In the fall, the shores are ablaze with a color palette of reds, yellows, pinks and golds from swamp maples, elders and oaks, complimented by greens from pines and hollies. The dark, acidic water reflects the sky and riverbanks as perfectly as a mirror. We are privileged to own a small 50-year-old log cabin right on the water, together with a painter's studio with two views of the Great Egg Harbor River. This enjoyment of the river necessitates use of a canoe or kayak as the scene changes around every bend and with every change of light. Most people who populate South Jersey are completely unaware of the visual magic presented by small rivers such as this. These photos and paintings may well be your first look at this beauty in your backyard.

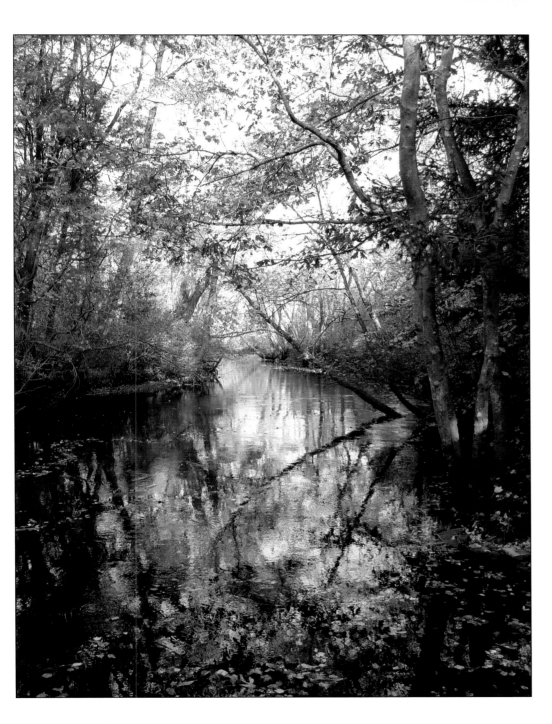

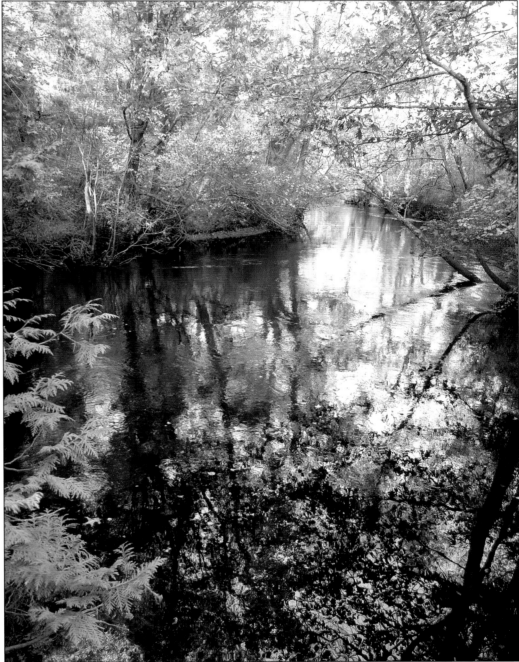

Hues on the River

I've included some photographs of the Great Egg Harbor River to illustrate that there has been little exaggeration of the color intensity and variety of hue seen upon these highly reflective waters. Fortunately this river is part of the federal wild and scenic river system and is protected against any further development along its banks.

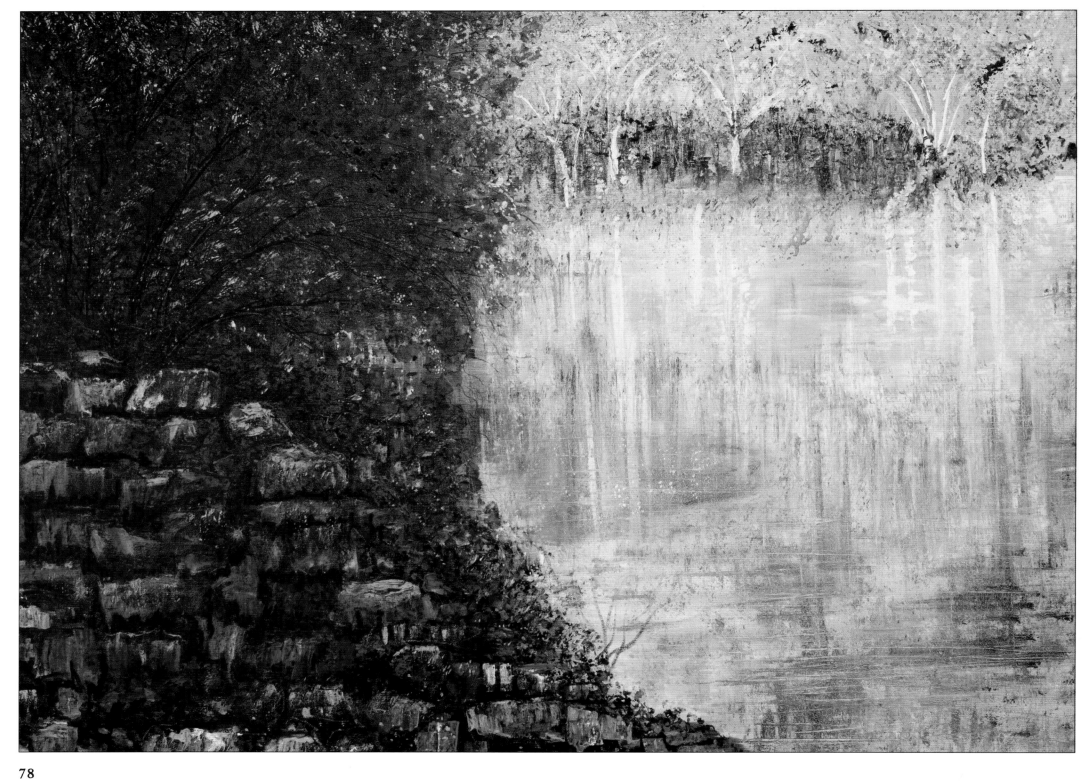

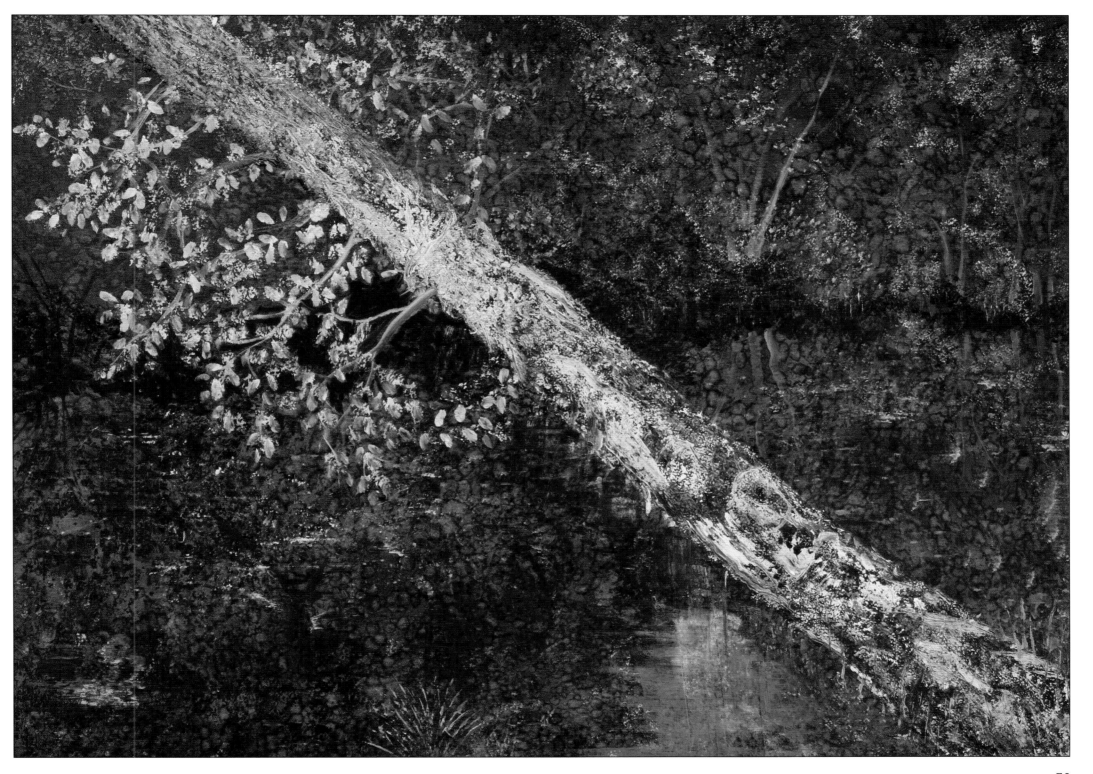

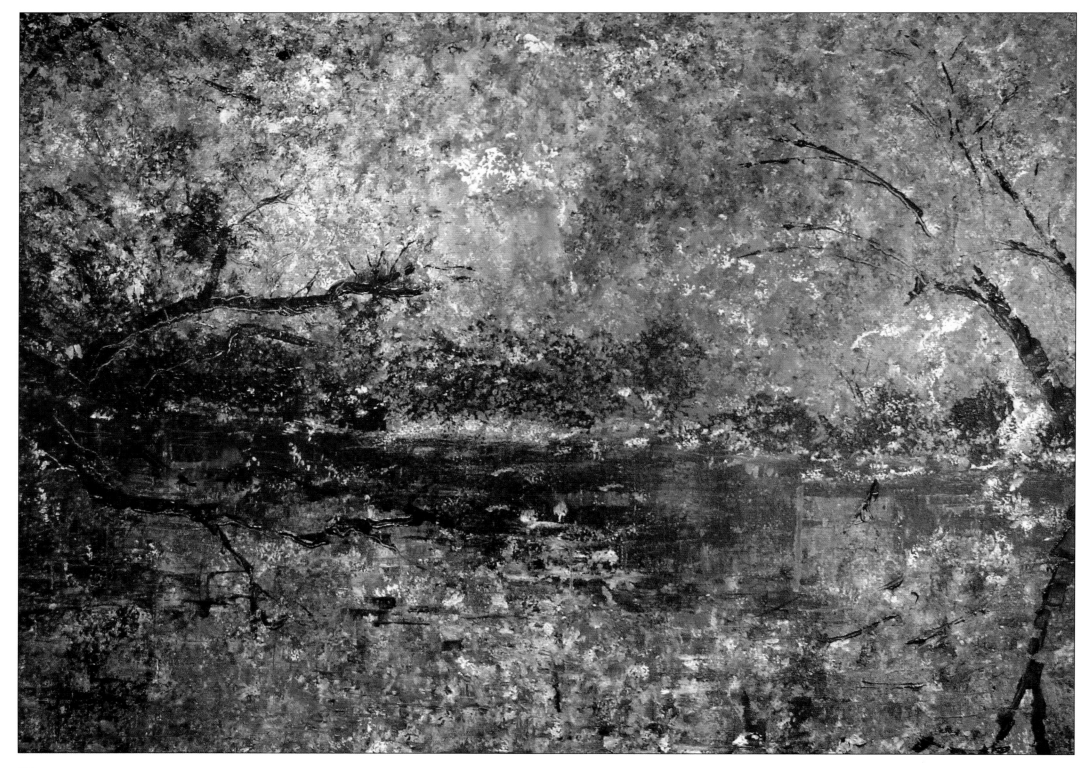

River Run Cabin

2001

11 x 14 oil on canvas

Having grown up in New York state in the foothills of the Adirondacks and summering at "camp" on pristine lakes, I felt something missing as an adult in New Jersey. In 1996 an advertisement appeared in the *Press of Atlantic City* real estate section for a secluded cabin on the Great Egg Harbor River. I'm not superstitious but I feel something drew me to this offering, since I had never before, or since, looked at this section of the paper. This began an artistic love affair with this remote and beautiful part of New Jersey.

River Run

The sweet smell of smoke and cedar
Waits at the door for its visitor
The sound and meter of the river
Deliver a sense of suspended motion
Sand, sun, moonlight and the pitch pine combine

Excerpt from River Run, *by David Clemans, 2001*

Left:
Fall On The Great Egg Harbor River

2002
30 x 40 oil on canvas
Courtesy of Tom and Peg Curran

Previous spread:
Stone Cove

2008
30 x 40 oil on canvas

Falling Tree Down River

2008
30 x 40 oil on canvas

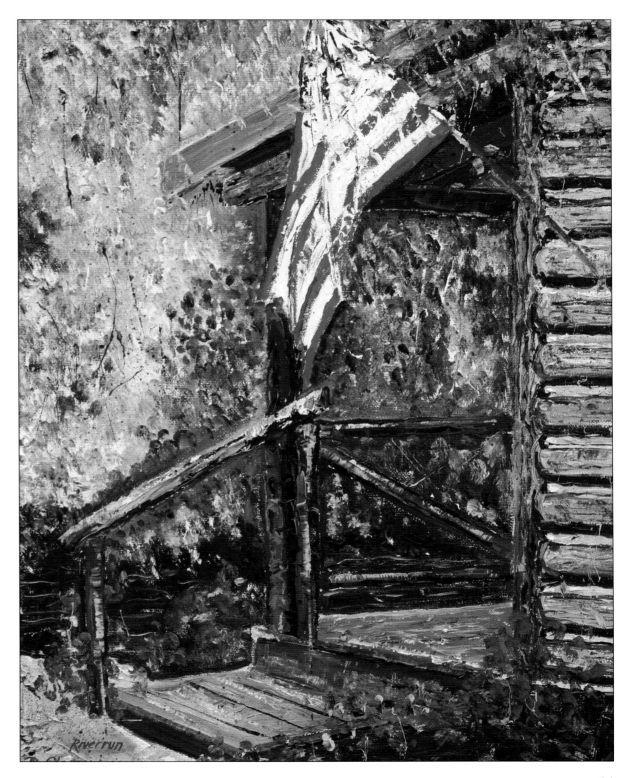

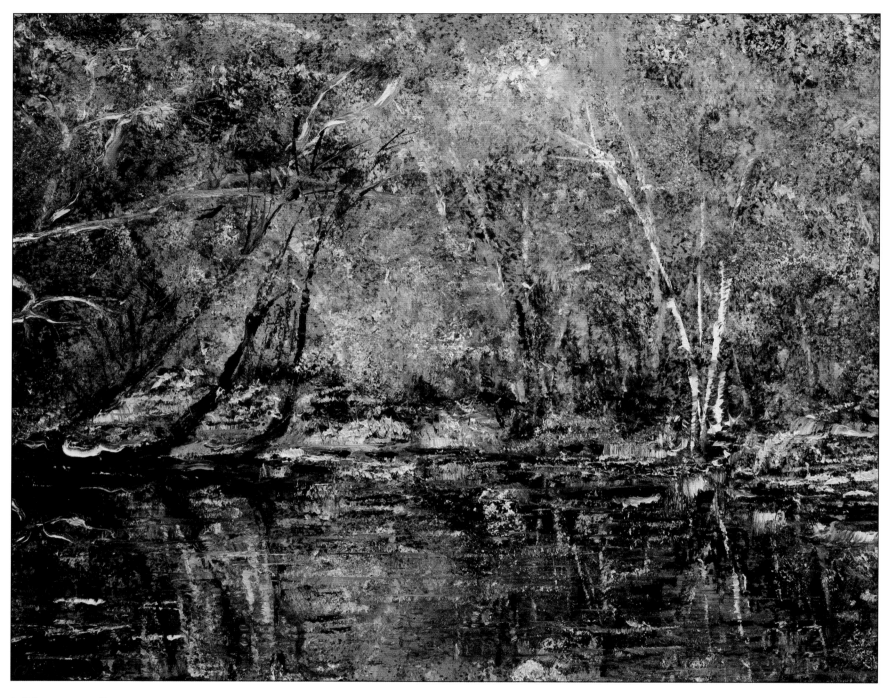

Midsummer Green

2001

24 x 30 oil on canvas

Road To River Run

2000

8 x 10 oil on canvas

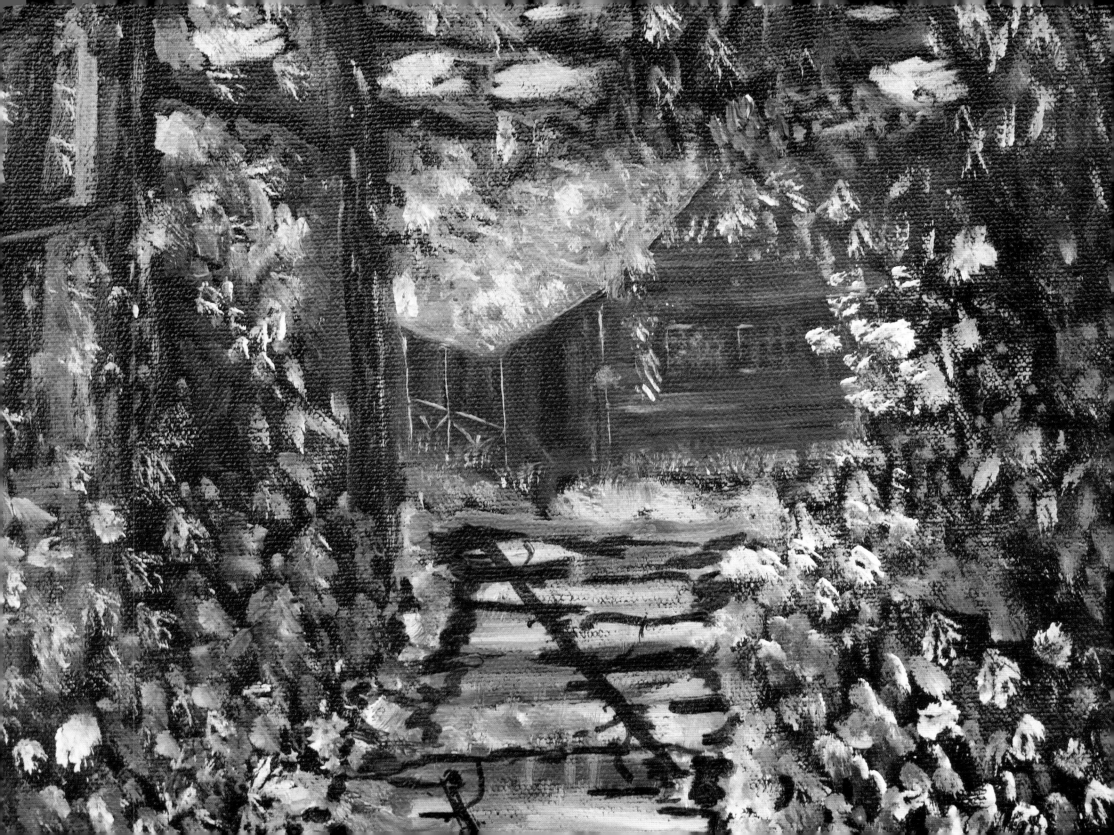

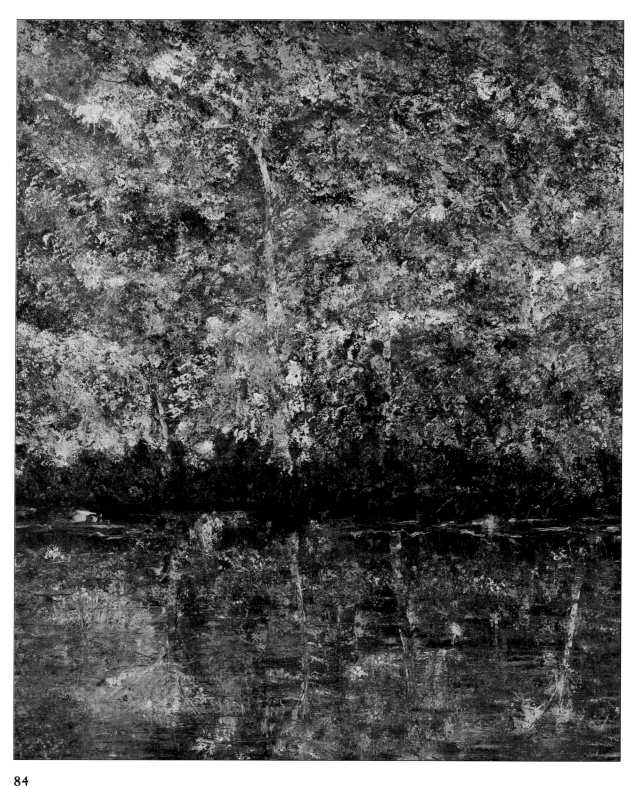

Pastel Waters
2005
24 x 30 oil on canvas

Twin Maples
2001
7 x 10 watercolor

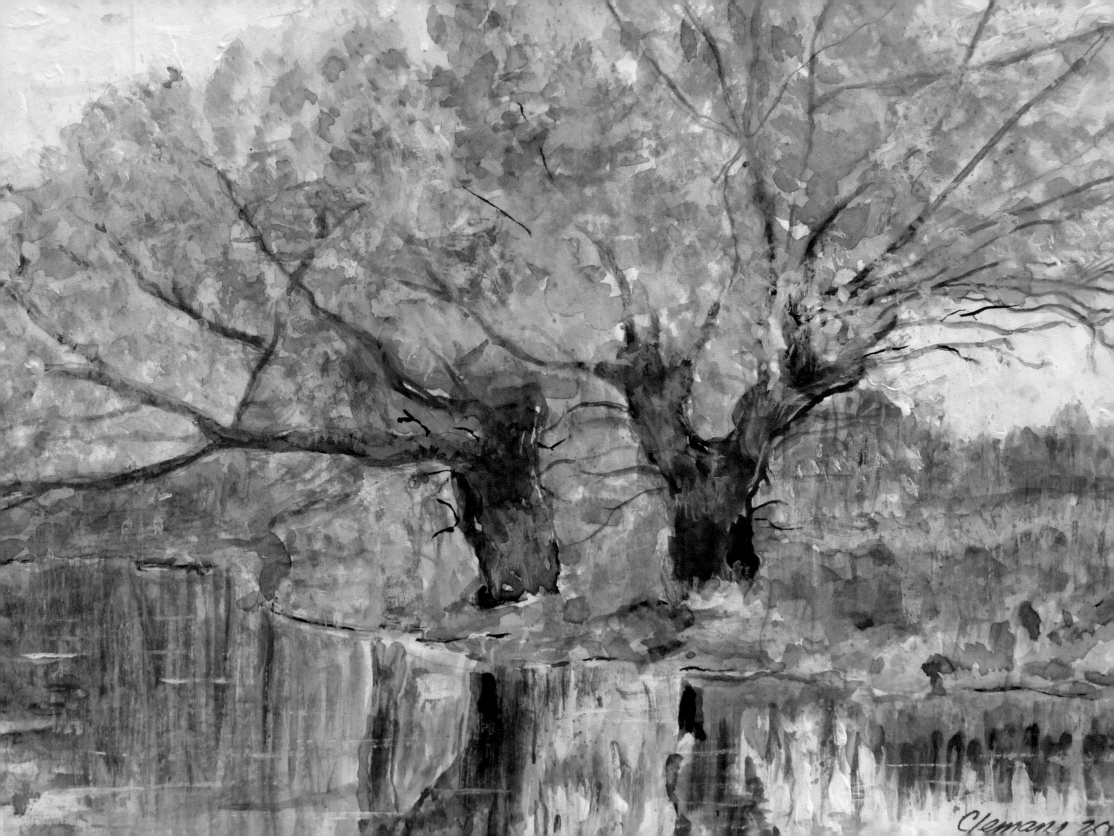

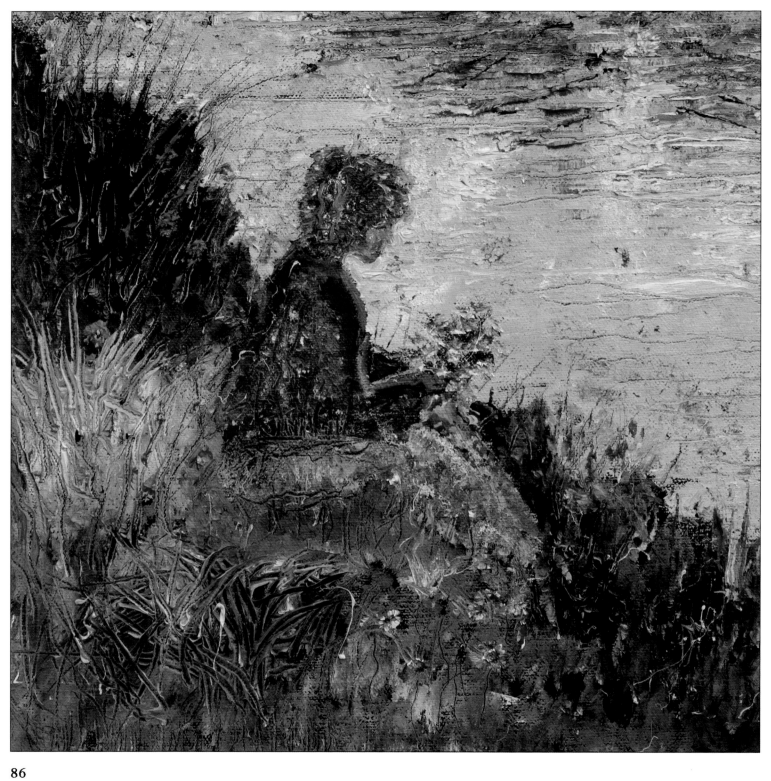

Solitude
2003
10 x 10 oil on canvas

Fun, Sun And Water

2003

10 x 10 oil on canvas

The sandy cove is alive with
the laughter of children.
Tow heads, curly heads,
all headed into the cold
embrace of riverrun.
Its wetness traces a line
across their splashing legs.
Soon lost to the shower of
water and joy.

Excerpt from River Run, *by
David Clemans, 2001*

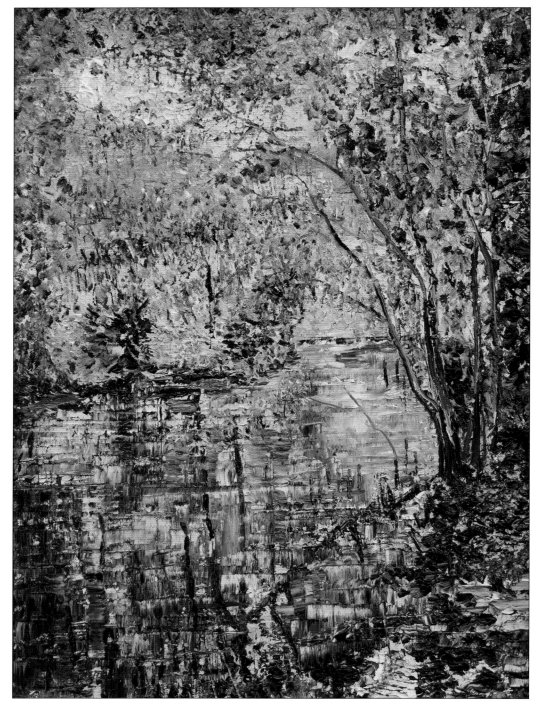

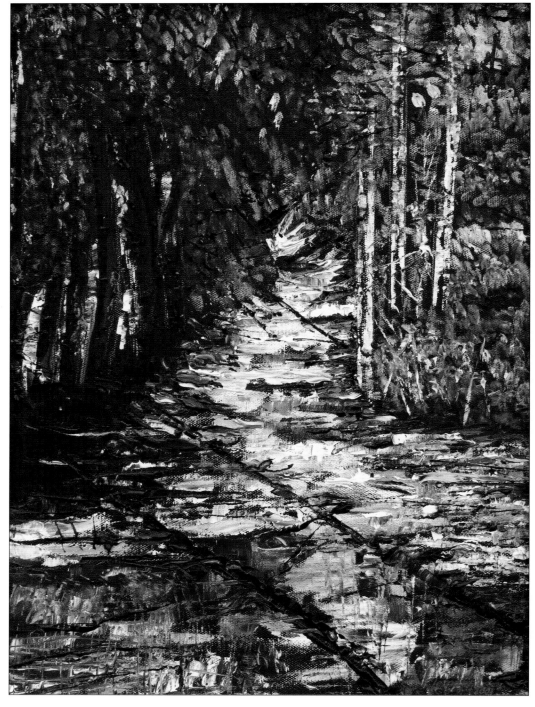

River In Springtime *2001* 12 x 16 oil on canvas **Cabin Path** *2001* 12 x 16 oil on canvas **Fall Down River** *1997* 8 x 10 oil on canvas

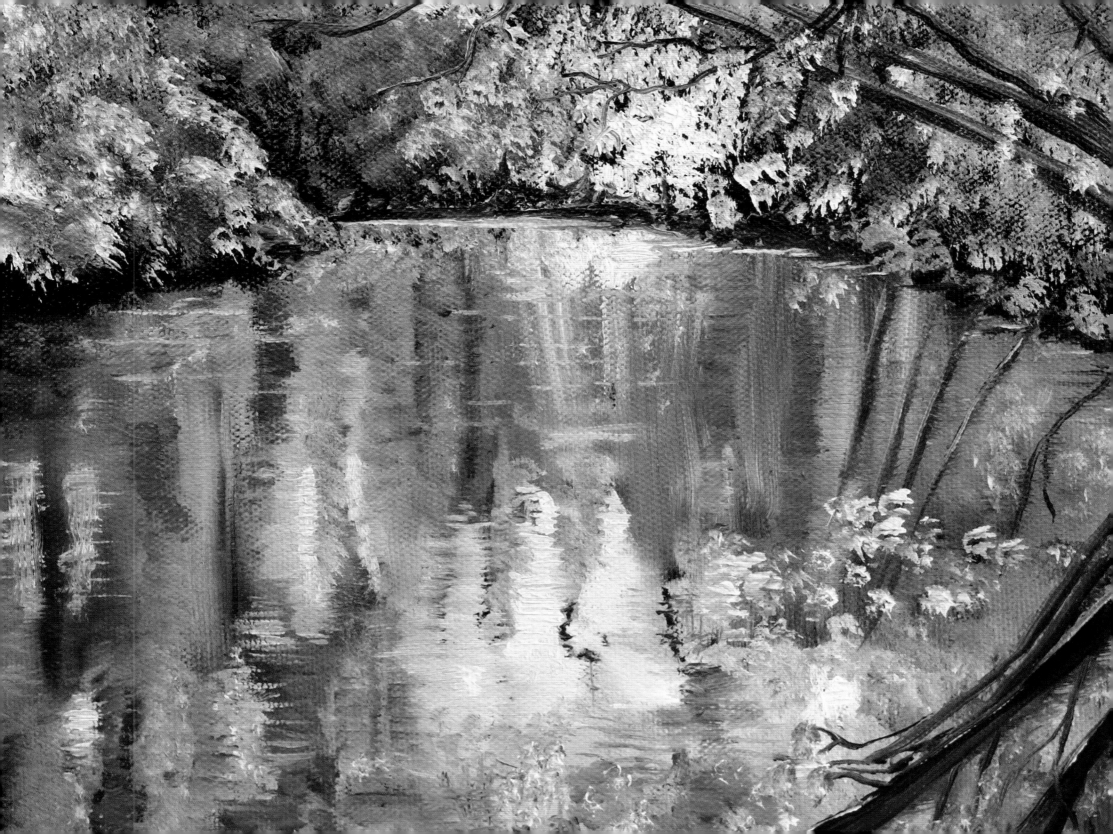

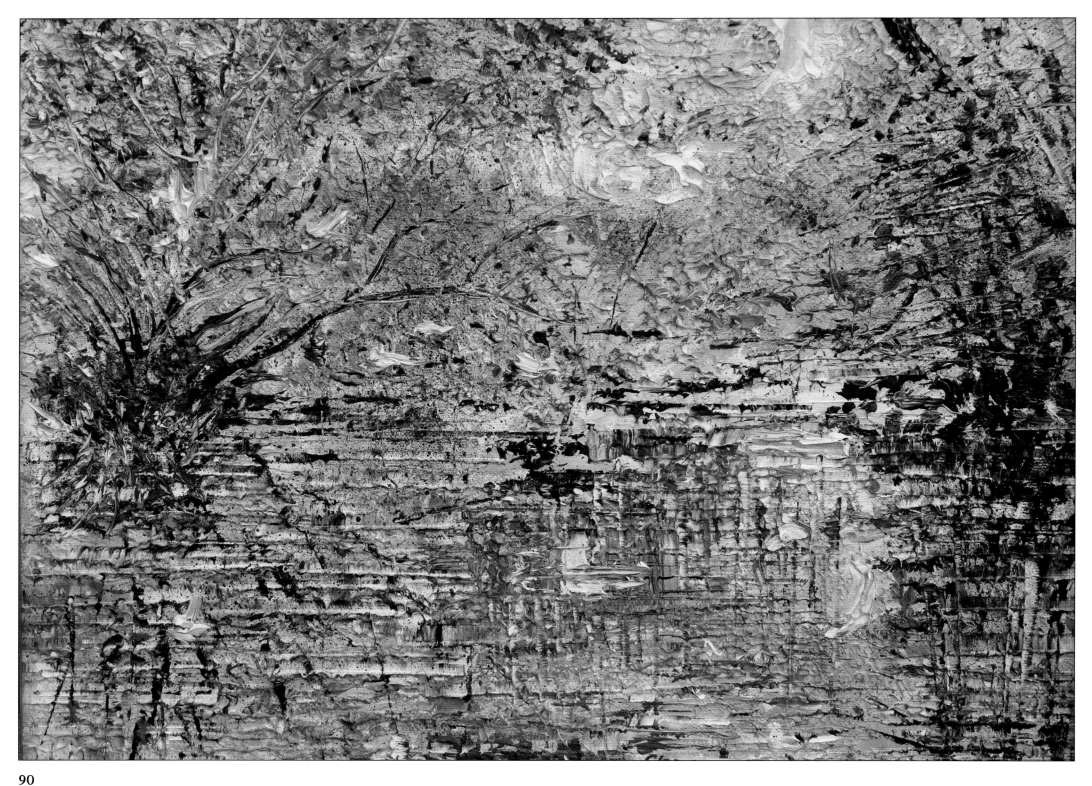

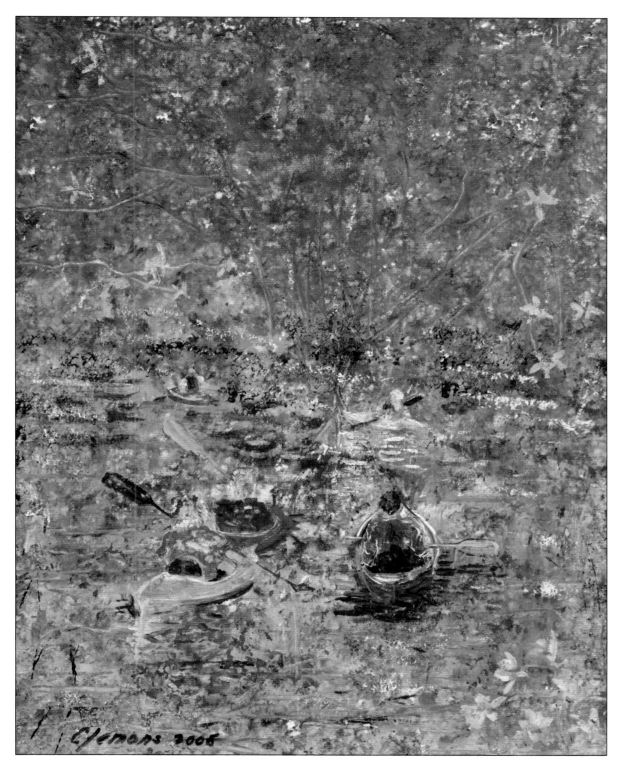

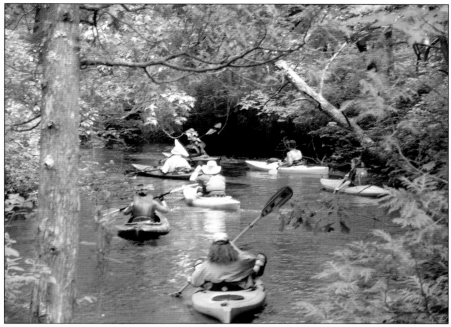

Kayak Parade
2005
11 x 14 oil on canvas

Sounds on the river echo in
my memory.
Round the bend paddles dip
and lift in unison.

Excerpt from River Run, *by
David Clemans, 2001*

Opposite page:
Fall Palette
2001
11 x 14 oil on canvas

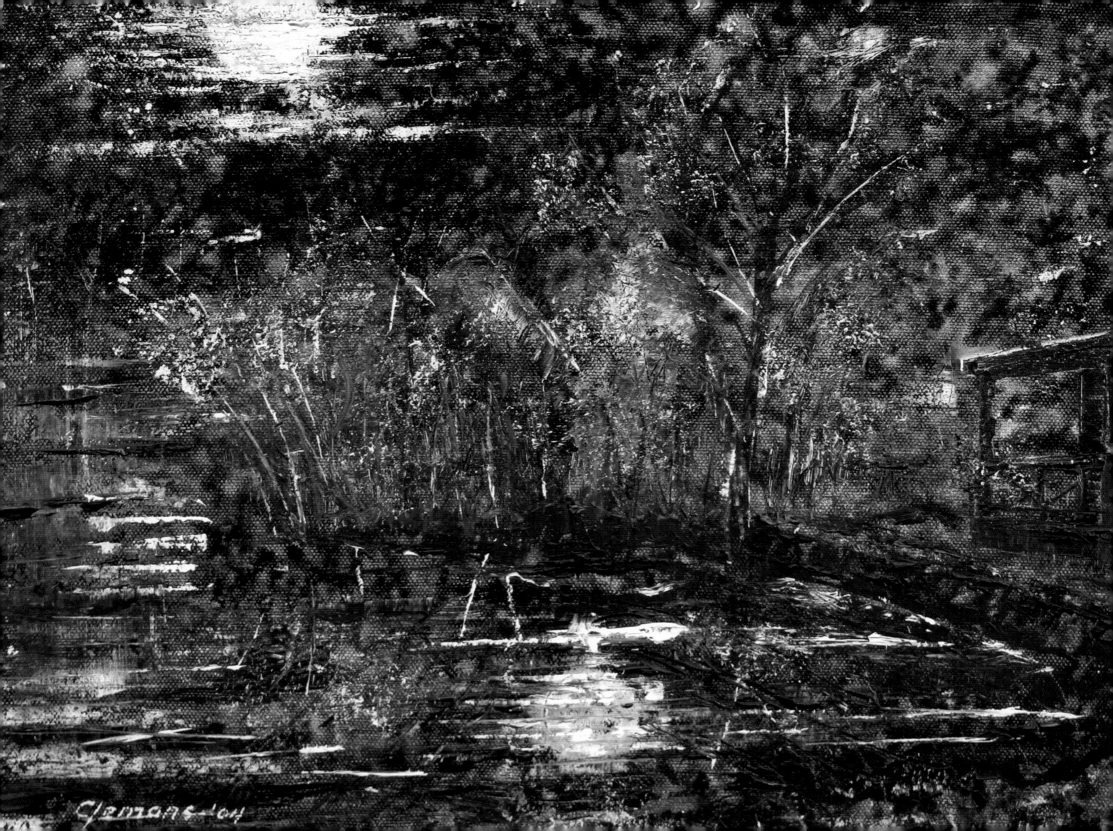

Nocturnes

I have been fascinated for years with the nocturnes of James McNeill Whistler, in particular *Nocturne In Black And Gold: The Falling Rocket* from 1875, shown right His work has inspired several of my paintings.

Cabin Cove By Moonlight
2004
12 x 16 oil on canvas

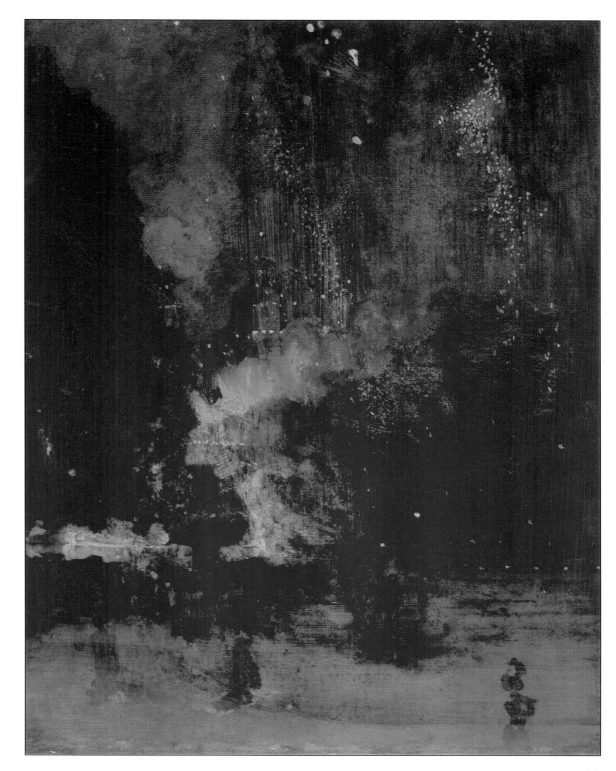

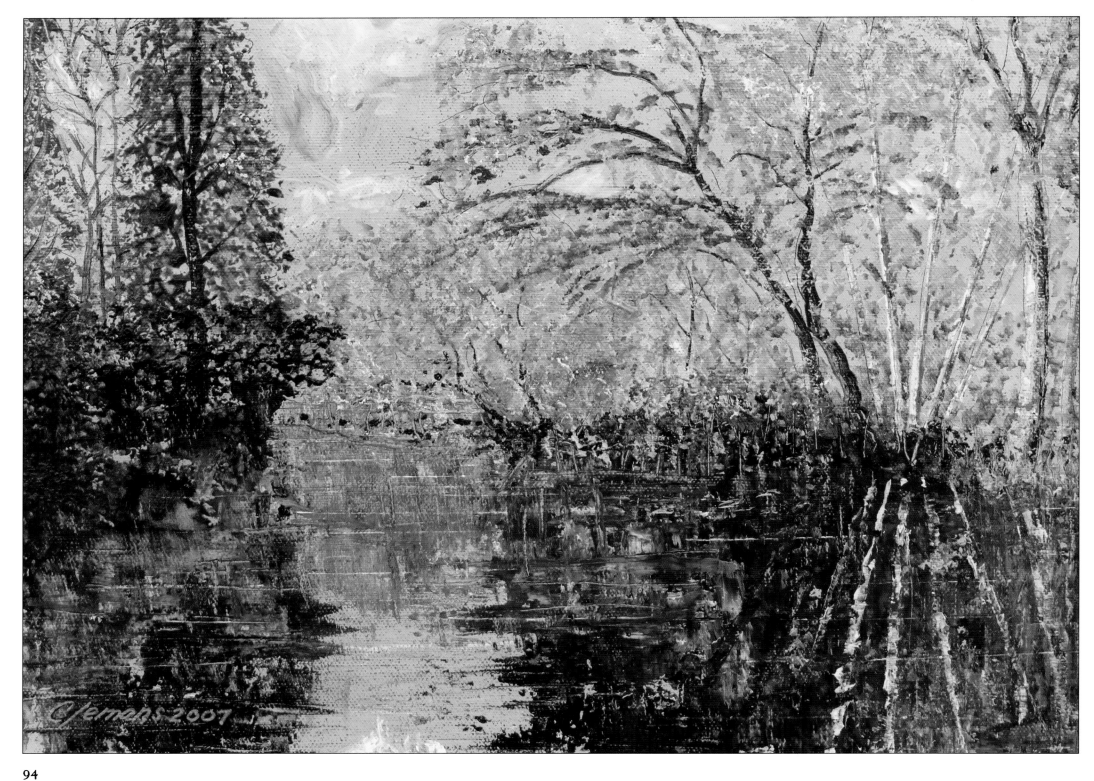

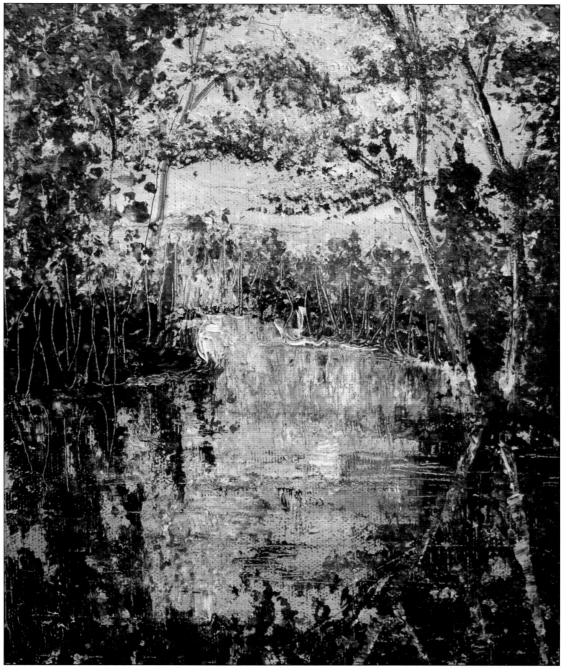

River Blues *2007* 11 x 14 oil on canvas **Snow Covered Cove** *1998* 5 x 7 oil on canvas **Around The Bend** *2007* 8 x 10 oil on canvas

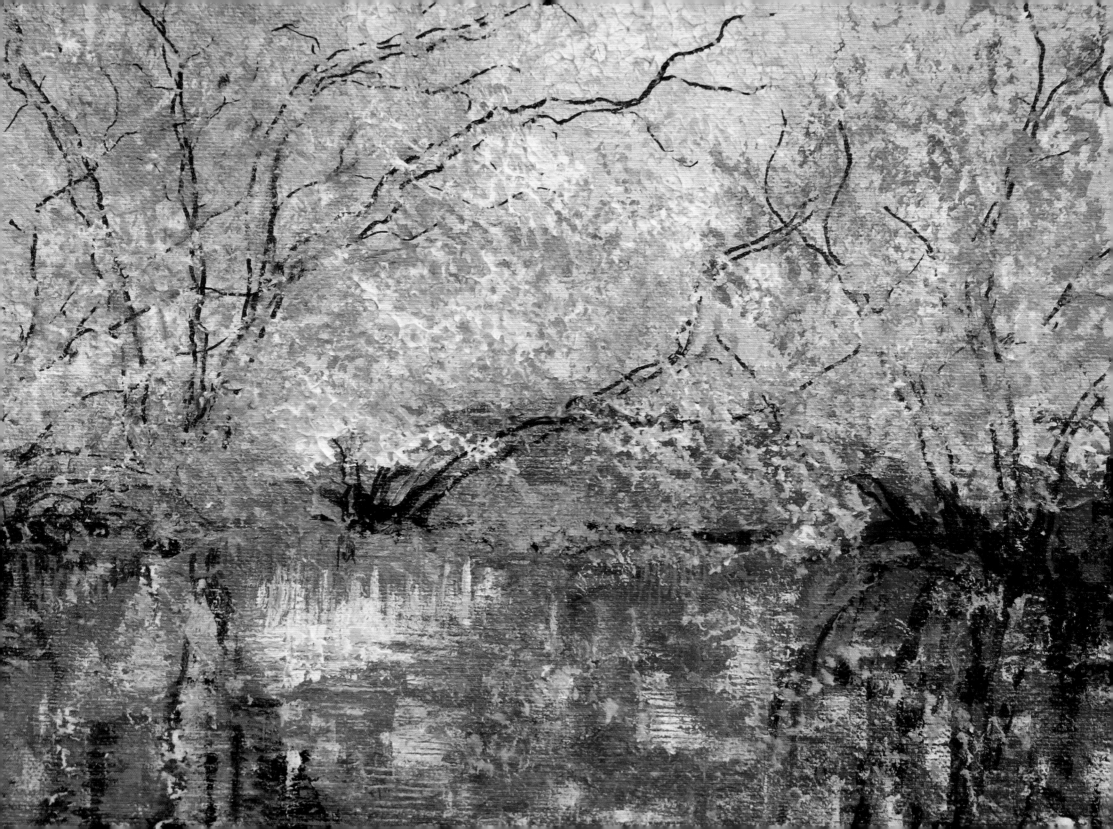

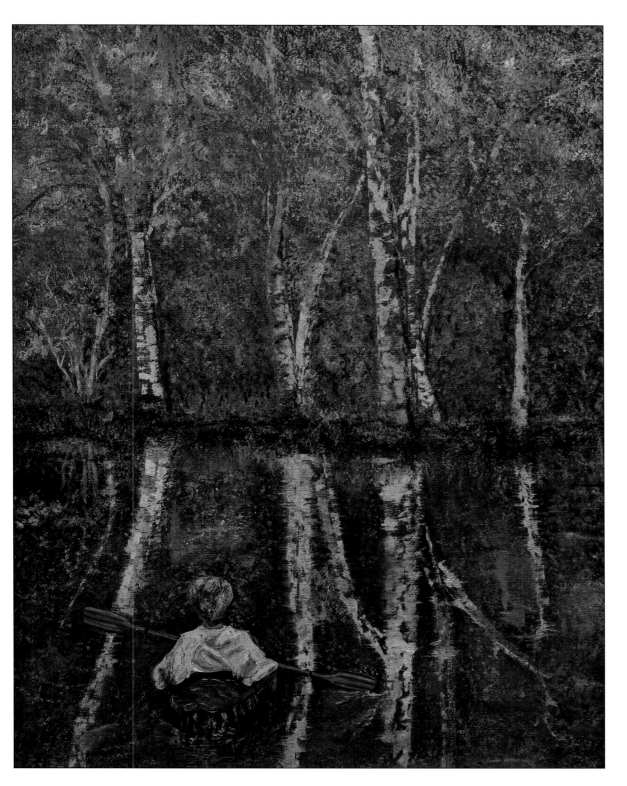

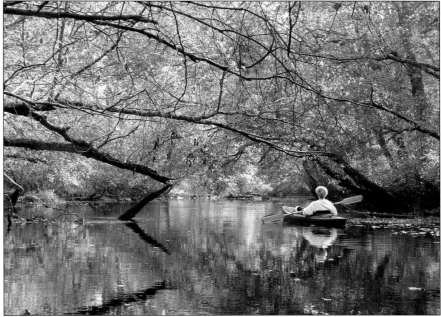

Opposite page:
Down River At Dusk
2005
8 x 10 oil on canvas

Reflections
2006
30 x 40 oil on canvas
I followed Christina on an afternoon kayaking
trip in the fall and took photographs along the way.

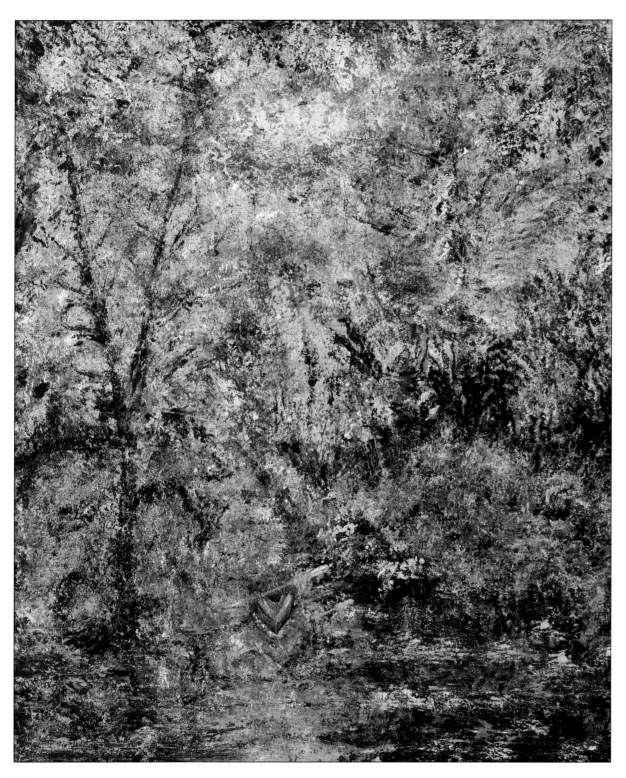

Coming Into View

2004
24 x 30 oil on canvas

The sun projects a vision on the dark water
Sliced by the narrow green hull
We lull in the lushness of the morning's warmth
Awaiting the approaching turn.

Excerpt from River Run, *by David Clemans, 2001*

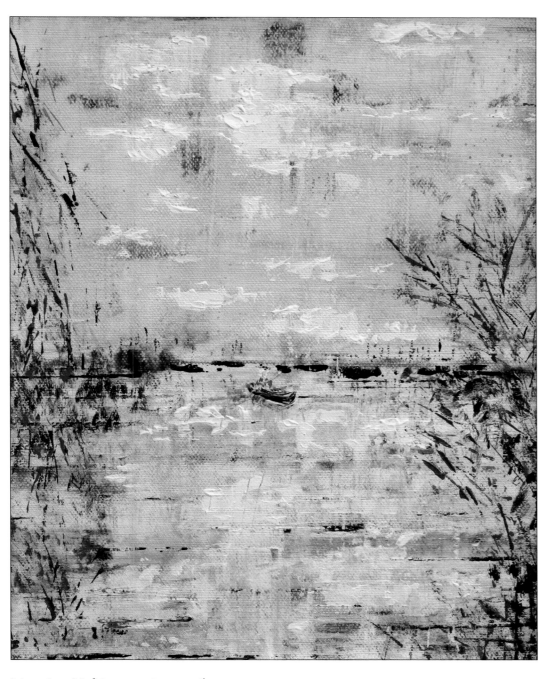

Morning Light 2005 8 x 10 oil on canvas

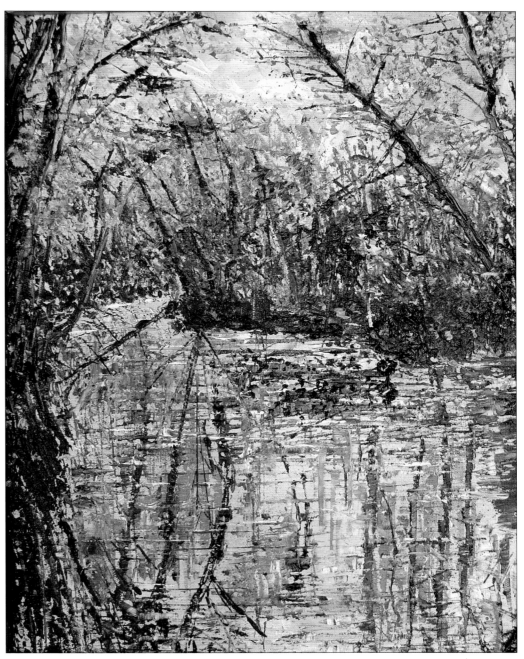

Yellow And Orange Bend 2001 12 x 16 oil on canvas
Courtesy of Tom and Peg Curran

Still Life &

Personal

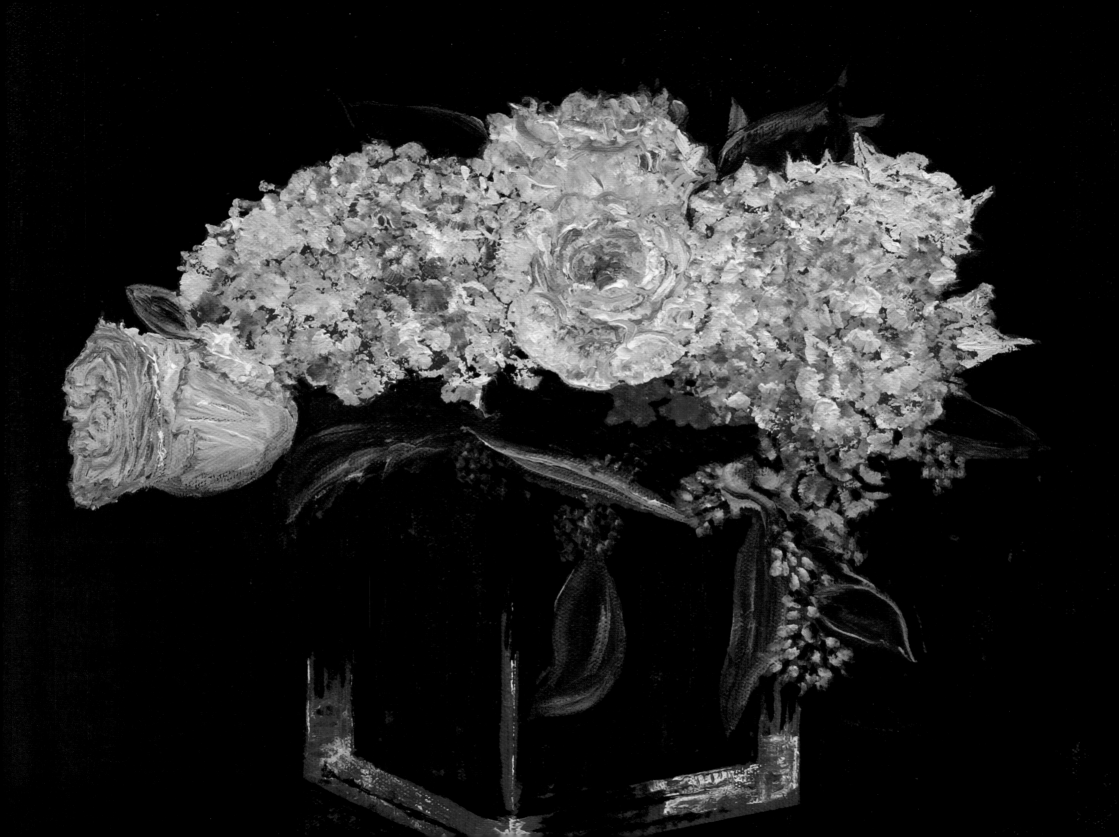

Still Life and Personal

Still life painting is an irresistible by-product of gardening, particularly if one has a collecton of interesting vessels in which to arrange freshly-cut flowers, fruits, stems and buds. I also enjoy presenting single specimens with no container as a naturalist would in a sketch book. There are also paintings in this section which were created for special reasons, either sentimentality or humor that don't fit any established category. I've included some of these at the end of this section as personal paintings.

Roses And Hydrangeas In Cobalt Vase
2007
12 x 16 oil on canvas

Previous spread: **Dance Of The Chillis**
1993
12 x 24 oil on canvas

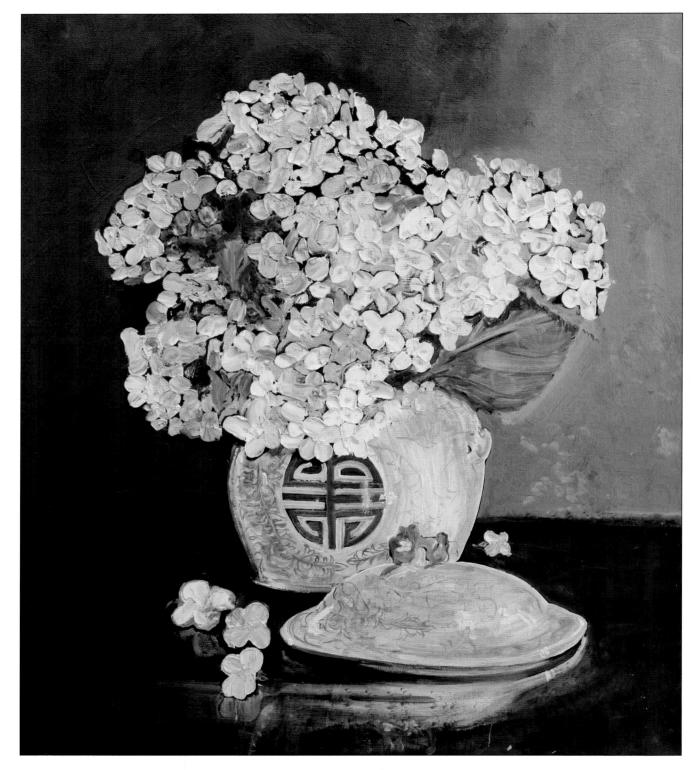

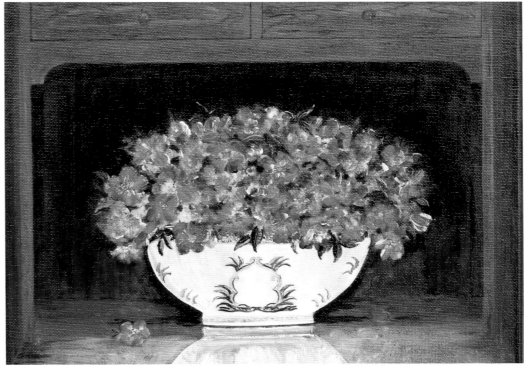

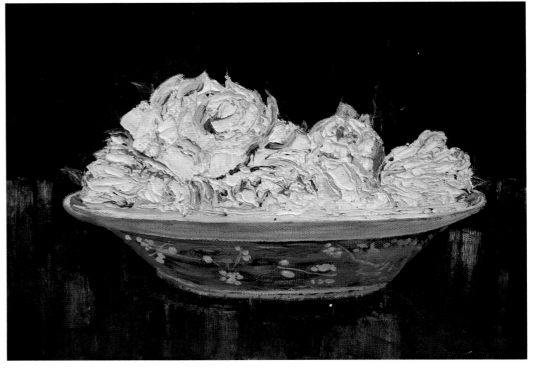

Opposite page:

Garden Bouquet
1987
8 x 10 oil on canvas

Pink Roses In Silver Bowl
1992
10 x 12 oil on canvas

Hydrangeas In Chinese Pot
1998
20 x 24 oil on canvas

This page:

Hydrangeas In Chinese Bowl
1998
10 x 12 oil on canvas

Red, White And Blue
1998
10 x 12 oil on canvas

Peonies In Flow Blue
2005
9 x 12 oil on canvas

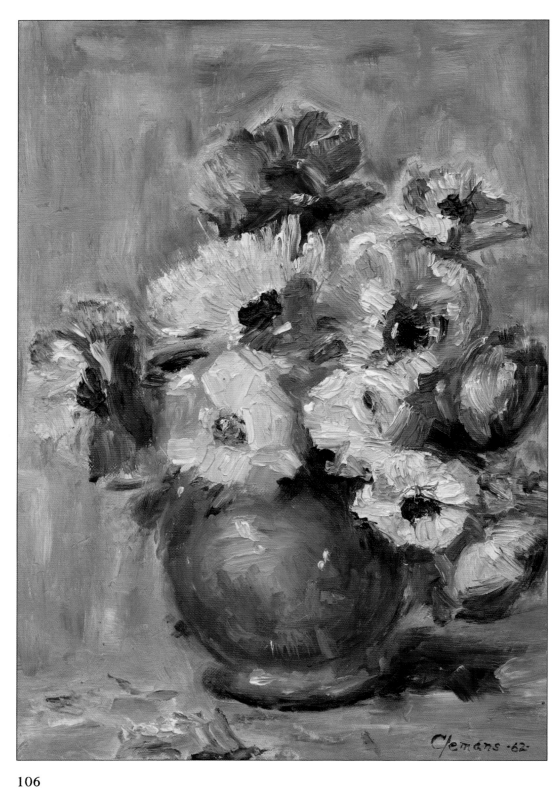

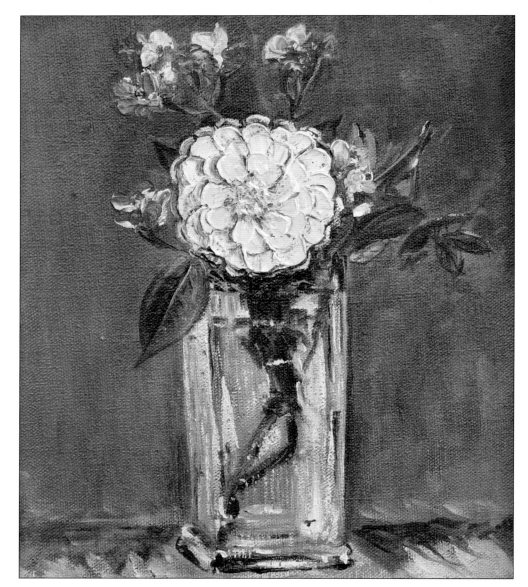

Anemones In A Copper Vase

1962

11 x 14 oil on canvas

After Manet

1991

8 x 10 oil on canvas

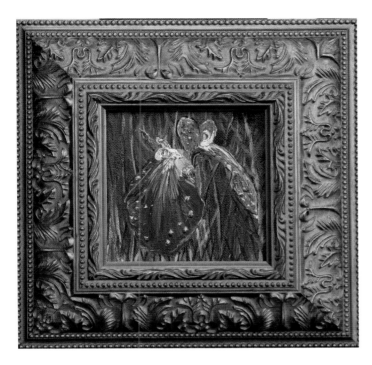
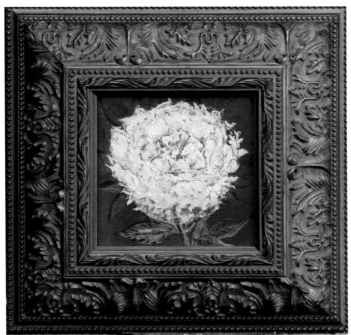
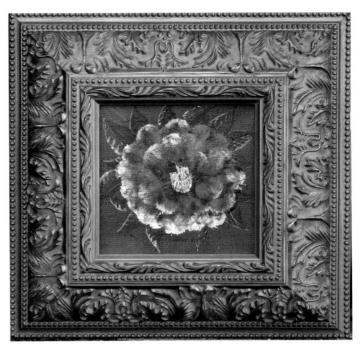
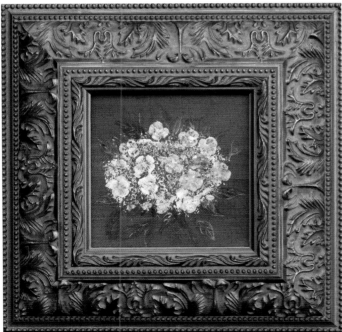
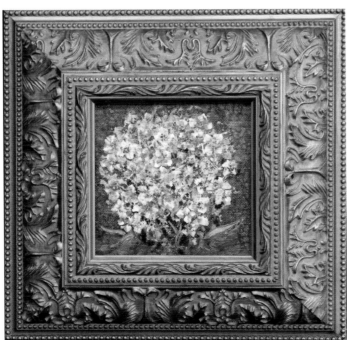

Assorted paintings, clockwise from top left:
Purple Iris Pink Peone Red Camelia Water Lily Blue Hydrangea Lace Cap Hydrangea *all 1997* 5 x 5 oil on canvas

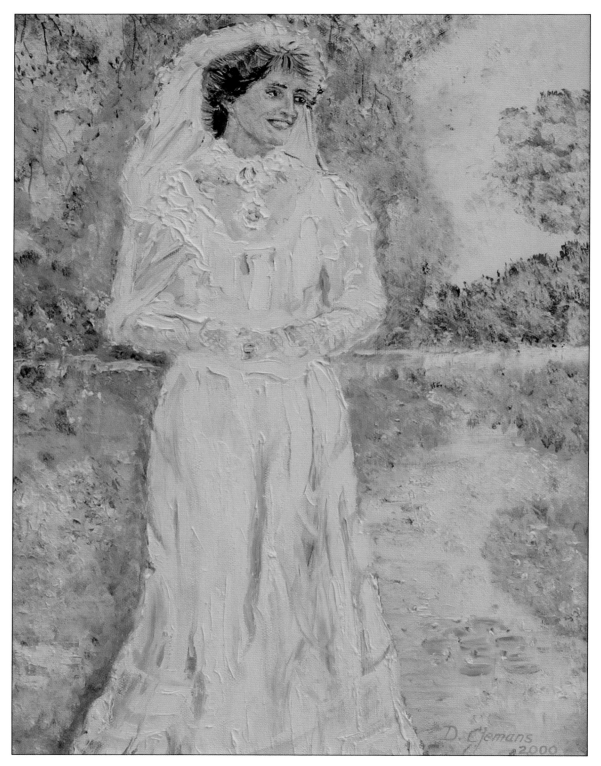

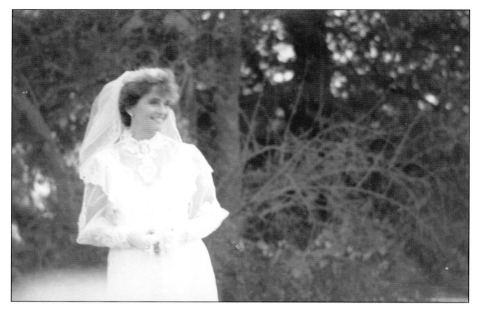

Artist's Bride

2000

12 x 16 oil on canvas

This painting has Christina dressed as a bride in a vintage wedding dress. This was part of a fashion show sponsored by the Mid-Atlantic Center for the Arts in the 1980s.

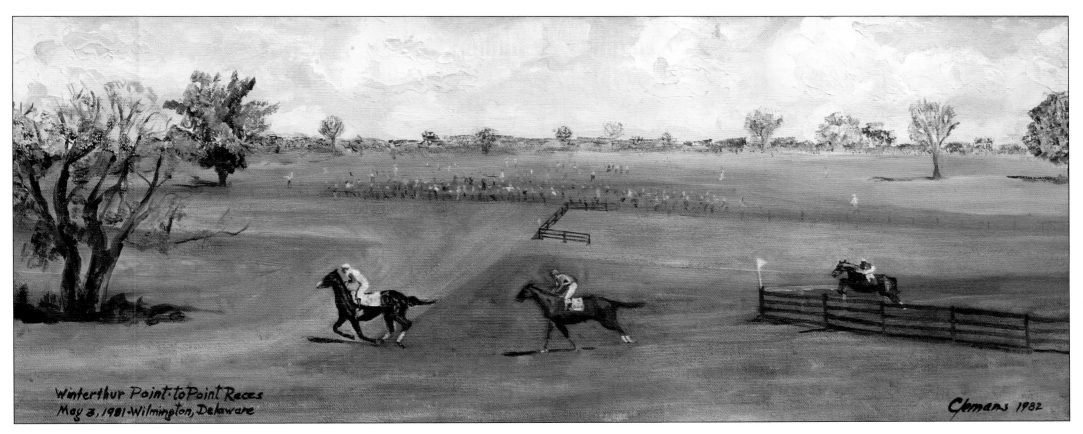

Winterthur Point-toPoint Races
May 3, 1981-Wilmington, Delaware

Clemans 1982

Winterthur Point-To-Point

1982
10 x 24 oil on canvas

The Winterthur Point-To-Point races
continue to this day in Wilmington,
Delaware.

Illustration courtesy of Winterthur *magazine*

109

Christina, Superstar
2005
11 x 14 oil on canvas

Artist's Father And Aunt, Circa 1920

2001

11 x 14 oil on canvas

I love this sepia-toned photograph, which was shot near my home town of Gloversville, New York.

Acknowledgements

For some years now my friends and family have urged that I abandon my reclusion regarding my paintings and share them with a wider audience, and with the particular prodding of my wife, Christina, I've now acquiesed.

I can paint pictures and write a few lines, but I could not have created this book. I must give absolute credit to designer, editor and publisher Jack Wright, a genius of spatial form and color.

I wish also to thank Victor Grasso, a supremely talented and passionate artist, for all his help and encouragement.

To my dear friend Jim Moffatt, I'm a painter, remember, so I don't know if I have the words to tell you how much I appreciate your continuous support in all matters.

And Tom and Sue Carroll... even though you've so far resisted the temptation to purchase my work, I've recently seen signs of increased appreciation. I am proud to call both of you my friends for four decades.

I would also like to thank Tom and Peg Curran who have supported me both by their friendship – and by collecting my work. (My favorite river painting, in fact, hangs in Tom's office at Curran Investment on Lafayette Street – I rather miss it, to tell the truth.)

And I'm grateful for the support of Sandy Miller and Cindy Schmucker through many years of friendship.

Finally, those beautiful gardens and buildings that continue to inspire me would not be there if it were not for the loyal support and dedicated artistry of Lew Thomas and George Lowry.

Three Sentries *1998* 18 x 24 oil on canvas
This painting depicts pitch pines on the bank of the Great Egg Harbor River.

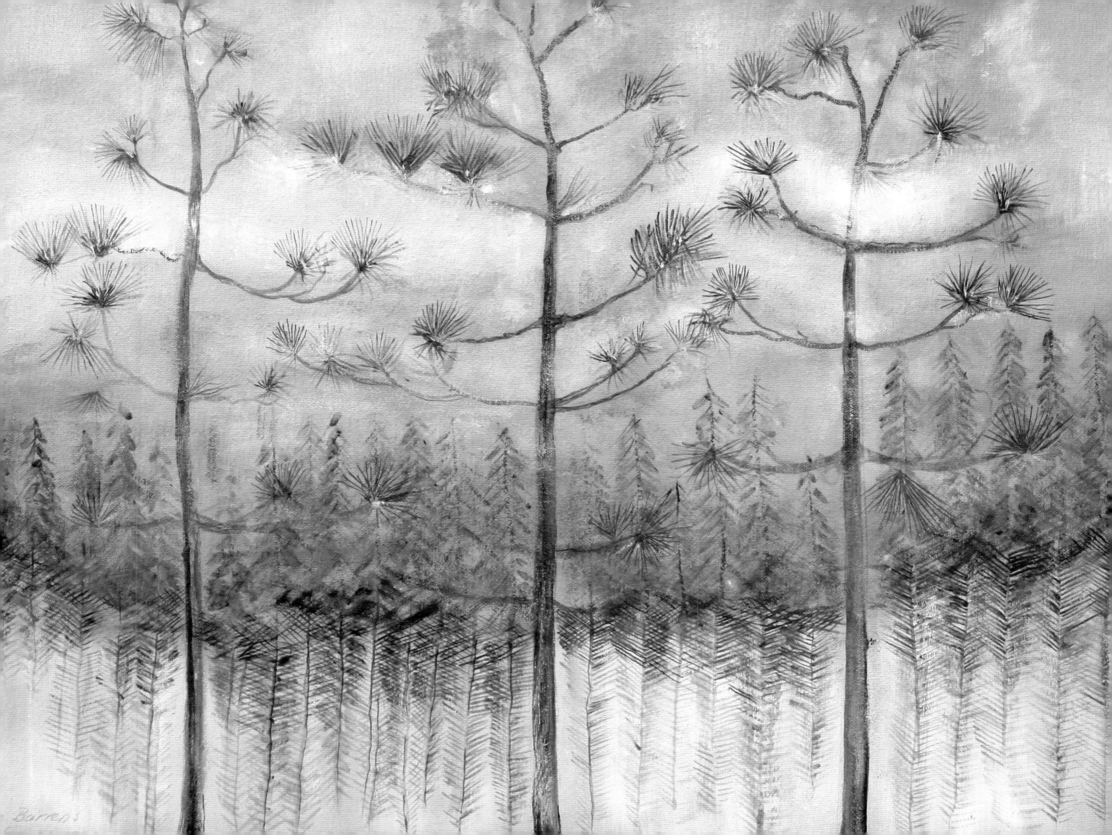